POWERFUL MUSHROOMS

The contents of this book are the result of research and studies conducted by the author. It's crucial to consult an expert before you harvest, use, or consume mushrooms. The publisher denies any responsibility for the choice to consume the fungi presented in this book.

POWERFUL MUSHROOMS
AN ILLUSTRATED ANTHOLOGY

FEDERICO DI VITA

Illustrations by
FLORENCIA DIAZ

CONTENTS

◆ 7 ◆
INTRODUCTION: THE POWER OF FUNGI

◆ 11 ◆
DELICIOUS FUNGI

Porcino (*Boletus edulis*) 13	**Black Trumpet or Horn of Plenty** (*Craterellus cornucopioides*) 26
Caesar's Mushroom or Ovolo Buono (*Amanita caesarea*) 14	**St. George's Mushroom** (*Calocybe gambosa*) 29
Matsutake (*Tricholoma matsutake*) 17	**Little Oak Porcino or Orange Bolete** (*Leccinum rufum*) 30
Piedmont White Truffle (*Tuber magnatum*) 18	**Parasol Mushroom** (*Macrolepiota procera*) 33
Miller Mushroom or Sweetbread Mushroom (*Clitopilus prunulus*) 21	**Corn Smut** (*Ustilago maydis*) 34
Hen-of-the-Wood or Maitake (*Grifola frondosa*) 22	***White Truffle Fair in Alba, Italy*** 37
Ox Tongue or Beefsteak Polypore (*Fistulina hepatica*) 25	

◆ 39 ◆
VISIONARY FUNGI

Fly Agaric (*Amanita muscaria*) 41	**Willow Shield** (*Pluteus salicinus*) 50
Magic Mushrooms (*Psilocybe mexicana*) 42	**Green-Flush Fibercap** (*Inocybe aeruginascens*) 53
Ergot (*Claviceps purpurea*) 45	**Magic Cone Cap, Ya'nte, Ta'a'ya, or Tamu** (*Conocybe siligineoides*) 54
Laughing Gym (*Gymnopilus junonius*) 46	**Panther Cap** (*Amanita pantherina*) 57
Brown Hay or Mower's Mushroom (*Panaeolus foenisecii*) 49	***María Sabina*** 58

61

POISONOUS FUNGI

Death Cap (*Amanita phalloides*) 63	**False Morel** (*Gyromitra esculenta*) 72
Valley Fever Fungus (*Coccidioides immitis*) 64	**Fool's Webcap** (*Cortinarius orellanus*) 75
Fool's Mushroom or Spring Destroying Angel (*Amanita verna*) 67	**Common Earthball or Pigskin Poison Puffball** (*Scleroderma citrinum*) 76
Olive Mushroom (*Omphalotus olearius*) 68	**Funeral Bell** (*Galerina marginata*) 79
Satan's Bolete (*Rubroboletus satanas*) 71	***R. Gordon Wasson and Valentina Pavlovna*** 81

83

MEDICINAL FUNGI

Almond Mushroom or Mushroom of the Sun (*Agaricus subrufecens*) 85	**Reishi** (*Ganoderma lucidum*) 97
Meshimakobu, Song Gen, or Sanghwang (*Phellinus linteus*) 86	**Shimeji or Beech Mushroom** (*Hypsizygus tessellatus*) 98
Chaga (*Inonotus obliquus*) 89	**Agarikon** (*Laricifomes officinalis*) 101
Chanterelle or Girolle (*Cantharellus cibarius*) 90	**Penicillium** (*Penicillium*) 102
Cordyceps (*Cordyceps militaris*) 93	***Paul Stamets*** 105
Lion's Mane (*Hericium erinaceus*) 94	

107

MYCORENEWAL

Oyster Mushroom (*Pleurotus ostreatus*) 109	**Turkey Tail or Coriolus Versicolor** (*Trametes versicolor*) 121
Shaggy Ink Cap or Shaggy Mane (*Coprinus comatus*) 110	**Cultivated Mushroom or Champignon** (*Agaricus bisporus*) 122
Elm Oyster Mushroom (*Hypsizygus ulmarius*) 113	**King Stropharia or Wine Cap** (*Stropharia rugosoannulata*) 125
Indian Oyster Mushroom (*Pleurotus pulmonarius*) 114	**Crust Fungus** (*Phanerochaete chrysosporium*) 126
King Trumpet or King Oyster Mushroom (*Pleurotus eryngii*) 117	***Amazon Mycorenewal Project*** 129
Shiitake (*Lentinula edodes*) 118	

131

INCREDIBLE (OR BIZARRE) FUNGI

Zombie-Ant Fungus (*Ophiocordyceps unilateralis*) 133	**Lantern Fungus or Basket Stinkhorn** (*Clathrus ruber*) 142
Flor-de-Coco (*Neonothopanus gardneri*) 134	**Brewer's Yeast** (*Saccharomyces cerevisiae*) 145
Jack-o'-Lantern Mushroom (*Omphalotus illudens*) 137	**Common Stinkhorn** (*Phallus impudicus*) 146
Fairy Ring Mushroom (*Marasmius oreades*) 138	**A Lichen (That Survives in Outer Space)** (*Circinaria gyrosa*) 149
Swamp Beacon (*Mitrula paludosa*) 141	**Koji** (*Aspergillus oryzae*) 150
	Wood Wide Web 153

INTRODUCTION: THE POWER OF FUNGI

iological life on Earth is divided into three large categories, and we usually refer to these groups into which living organisms are classified as kingdoms: the animal kingdom, the plant kingdom, and the kingdom of fungi. Yet, unlike the first two, little is generally known about the kingdom of mycetes: fungi are overlooked and underrated, and only recently have we begun to discover that nearly everything on the planet depends on them. It truly is hard to fathom just how true this is. Did you know that fungi brought plants out of the oceans five hundred million years ago, functioning as their roots for tens of millions of years? Or that by producing fifty megatons of spores each year, they can influence the weather by triggering the formation of rain droplets? Or that the planet's appearance depends on the endless network of hyphae that holds it together, and without which the soil would be washed away by atmospheric agents? Even now, whenever a sliver of land emerges from the waves following a volcanic eruption, lichens—symbiotic organisms composed of fungi and algae—are the first creatures to settle on it, producing the soil on which plants will later proliferate. And it's the mycelia—those dense fabrics of filaments that make up fungi's true body—that weave together intelligent networks capable of establishing lines of communication,

through the exchange of information and nutrients, between all the trees in forests. This is what's referred to as the Wood Wide Web, to which over 90 percent of the world's plants are connected. Through its endless mycelial byways, plants and fungi trade water and nutrients, and we've yet to discover a plant that doesn't have some relationship of interdependence with fungi—but then the same is true for animals and, naturally, for us.

Fungi survive in our intestines and in outer space. They can be microscopic and they can be enormous: the largest living organism on Earth, located in Oregon, is an *Armillaria ostoyae* that extends for 890 hectares, or over 1,000 soccer fields. Fungi can do incredible things: the *Cladosporium sphaerospermum* prospers among the reactors of Chernobyl, feeding on radiation; others eat petroleum, plastic, even TNT. We owe fungi more than we can imagine: they provide us with food, certainly, and not merely due to the exquisite flavor of certain prized fruiting bodies—what we call mushrooms are simply the mycelium's fruit—but thanks to their alchemical capabilities.

Also a part of the fungal kingdom, in fact, are yeasts, capable of driving fermentation in alcohol and bread. Various molds were used to heal wounds even in bygone eras—in ancient Egypt, among the Australian aborigines, etc. The Talmud, one of Judaism's foundational texts, mentions *chamka,* a remedy made from corn mold and date wine. If these cures worked, it was due to the bacteria-killing properties of certain molds. In 1928, it was beginning precisely with one of these, *Penicillium notatum*, that Sir Alexander Fleming, a Scottish bacteriologist and pharmacologist, discovered penicillin, the first modern antibiotic and one of the most important drugs of all time.

If that weren't enough, moving into the realm of the intangible, fungi have given rise to vast parts of our cultural imagination and particularly to the spiritual root—or, we might say, the spiritual mycelium—from which whole cultures have drawn their life force. According to the theory of ethnobotanist and philosopher Terence McKenna, the development of language and culture in our prehistoric ancestors may have been accelerated by the use of mushrooms from the *Psilocybe* genus. McKenna suggests that the consumption of fungi containing psilocybin—the active ingredient in magic mushrooms—could have augmented visual perception, favored abstract thought, and improved social cohesion, thus contributing to the rapid development of human cognitive abilities. His intuition has seemed less far-fetched since researchers at London's Imperial College noticed how psychedelic experiences can facilitate—sometimes quite strongly—access to apical states of abstract thought, the chief

site of cognitive progress. Today, we know that psilocybin has significant therapeutic potential in treating a vast number of mental-health conditions. According to the website ClinicalTrials.gov, the largest database of clinical studies conducted around the world, there are currently 129 ongoing research projects involving psilocybin, investigating this molecule's potential to treat a host of disorders: clinical depression; fear of death in terminal patients; post-traumatic stress disorder; the abuse of alcohol, tobacco, and other substances; Parkinson's; bipolar and obsessive-compulsive disorder; Lyme disease; anorexia; cluster migraines; even fibromyalgia. In the gamut of antidepression treatments, the potential of psychedelic molecules is on the verge of establishing itself as truly revolutionary.

There are an estimated three million species of fungi in the world; we're familiar with only 6 percent of them.

The book you're holding is a small gateway to this universe, and I can assure you that it was far from simple to choose sixty of them in an exploration of their shapes, their uses, and their infinite potential.

DELICIOUS FUNGI

This book proves that fungi know how to do a great many things, but the first thing that we became aware of is not something they do but what they are: incredibly tasty. Not all of them, sure, as we've learned at our own expense. But when mushrooms are good, they can be one of the most exquisite delicacies around: sublime and intense aromas, fragrances of forest undergrowth, a consistency and texture worthy of haute cuisine . . . enough to leave your head spinning (and your stomach purring with delight).

DELICIOUS FUNGI

BOLETUS EDULIS

PORCINO

The porcino is the king of the woods. Legendary and versatile in the kitchen, we find it between late summer and autumn in a wide variety of forests and at a range of altitudes.

A mushroom with a taste that's universally renowned, thanks to its aroma of undergrowth with earthy, chestnut-like notes, a hint of sweetness, and a healthy dose of umami, the porcino grows individually and in small groups of two or three. The mycelium produces garish fruiting bodies with large reddish-brown caps whose color fades toward the edge. They get darker as they mature and can reach a diameter of 15.7 inches (40 cm) and a weight of 6.6 pounds (3 kg). The porcino has tubes instead of gills that release its spores when it matures. The stem is robust, white or yellowish, sometimes quite thick, bulging in the middle, and partially covered by a raised lattice. Its cap is slightly sticky to the touch, convex while young but tending to flatten out as it matures. The flesh is white, and it's thick and tough when the mushroom is young but becomes a bit spongy with age.

The porcino's mycelium forms symbiotic associations with trees, enveloping their roots with its dense fungal hyphae. Among edible mushrooms, it's considered one of the safest to pick, given their ease of identification to an experienced forager and the fact that there are few poisonous species that resemble it. It's found in habitats dominated by conifers, hemlocks, chinquapins, beeches, oaks, and so forth, though its organoleptic peak may be its association with chestnut trees.

Have you ever tasted a Borgotaro porcino? Thanks to its fleshy consistency—particularly when young—it's exquisite in a wide variety of recipes: raw in a salad, fried, grilled or sautéed with garlic and lesser calamint for a memorable pasta dish.

DELICIOUS FUNGI

AMANITA CAESAREA

CAESAR'S MUSHROOM OR OVOLO BUONO

The Caesar's mushroom is a genuine natural treasure, highly prized ever since ancient Roman times.

Delicious and coveted, the *Amanita caesarea* is typically found in the Mediterranean basin, where it's found in the undergrowth of oak and pine trees. It's a protected mushroom in various countries, and in the Ukraine it's considered to be at risk of extinction. While growing principally in southern Europe and North Africa, it can also be found in the Balkans, Hungary, India, Iran, China, and Mexico. Its cap, ranging from bright orange to yellow, can reach a diameter of 7.8 inches (20 cm) and has a smooth surface with slightly striated edges. Its stem varies from white to orange, growing as tall as 9.8 inches (25 cm).

In its younger stages, the *A. caesarea* has an oval shape and is wrapped in a universal veil, a structure that gradually tears as the mushroom grows, leaving a volva at the base of the stem and a skirt-shaped ring roughly halfway up. When its veil is closed, it's possible to confuse the *A. caesarea* with other species, even lethal ones like the *Amanita falloide*. Often, however, it's picked while still young, partly because it tends to appear in small groups whose mushrooms have different degrees of maturation. Its youthful appearance is at the root of its popular Italian name—*ovolo buono*—since at this stage it closely resembles a small egg, even more so when the orange of the cuticle peeks through the torn veil.

Its exquisiteness is legendary: in Italy, it's eaten raw, sliced thinly and served with slivers of parmesan cheese or with arugula, preparations that exalt its delicate flavor and slightly tough consistency. The *A. caesarea* is also used in more elaborate recipes, while some people serve it with fresh pasta after sautéing it with oil and garlic.

DELICIOUS FUNGI

TRICHOLOMA MATSUTAKE

MATSUTAKE

Known In Japan as the matsutake, this is perhaps the most gastronomically sought-after mushroom in the world. Belonging to the Tricholomataceae family, it's native to the pine forests of East Asia, northern Europe, and Japan, where it's considered a veritable delicacy.

The matsutake is a mycorrhizal mushroom that forms a symbiotic relationship with pine and beech trees. Indeed, it grows right around them, usually hidden in the forest's fertile undergrowth. Its earthy flavor, fleshy consistency, and sweet aroma, reminiscent of the smell of pine and certain spices, have made it a key ingredient in Japanese gastronomy. Such characteristics are crucial elements in numerous dishes, such as *matsutake gohan* (rice with matsutake) and sukiyaki (a rich dish typical of end-of-year festivities).

In Japan, the matsutake symbolizes fertility and good fortune. And up to the seventeenth century in the Land of the Rising Sun, only members of the nobility were allowed to eat them; it was also a common custom to exchange them as gifts in aristocratic circles. Beginning in 1940, however, matsutake production in Japan diminished drastically due to ecosystem problems, including pine disease. Consequently, other countries, primarily China, have become the main matsutake exporters.

This mushroom also has medicinal properties, since its compounds act as antioxidants that help limit the development of cancer cells. Its essential nutrients also include vitamin B3, vitamin D, and potassium. But beyond its therapeutic virtues, this mushroom ought to be enjoyed at the table as a refined delicacy. If you get the chance, make sure to taste it.

DELICIOUS FUNGI

TUBER MAGNATUM

PIEDMONT WHITE TRUFFLE

Known as the Piedmont white truffle, this fungus is a gastronomic gem, renowned for its inebriating aroma and exquisite flavor.

Behold the prince of truffles, the mushrooms of the nether world, bearing their fruit underground. Its fame is millennia old: as far back as ancient Rome, the *Tuber magnatum* has been a symbol of status and luxury. Originally from southern Europe, it's found above all in the Langhe and Monferrato regions in Piedmont, between Alba and Asti. In those areas, the hunt for white truffles, for which foragers use specially trained dogs, gives rise to genuine feuds. Pigs are even better than dogs at finding these truffles, but they aren't used because, aficionados that they are, they'd devour them instantly.

Every autumn, the town of Alba holds the Truffle Fair, a gastronomic event of the highest quality that celebrates this culinary jewel, attracting tourists and experts from around the world. The fair underlines not only the culinary value of *T. magnatum* but also its cultural and historical importance for the local territory. Another important center for the harvesting of this fungus is Acqualagna in Le Marche, well-known for its own annual white truffle festival.

The unique flavor and marked rarity make the white truffle one of the most sought-after ingredients in the most refined cuisines. Its exclusivity has deep roots in Italian gastronomy, where it's considered an ingredient of absolute excellence. Served raw, thinly sliced on a wide variety of dishes, white truffle releases an unmistakable aroma, capable of exalting and giving a touch of refinement to many a recipe. All it takes is a few little shavings of this mycete and your fried egg is launched into the stratosphere of Michelin-starred cuisine.

DELICIOUS FUNGI

CLITOPILUS PRUNULUS

MILLER MUSHROOM OR SWEETBREAD MUSHROOM

The edible miller or sweetbread mushroom is prized for its aroma between prune and cucumber, with notes of raw dough.

This pink-spored mushroom—technically a basidiomycete—grows mainly in Europe and North America, in meadows and in coniferous and broadleaf forests, frequently on the coast north of San Francisco beneath Bishop pines (*Pinus muricata*). The miller mushroom was first described in 1772 by Tyrolean naturalist Giovanni Antonio Scopoli, who called it *Agaricus prunulus*, a classification corrected in 1871 by German botanist Paul Kummer.

Its cap, which varies from gray to white and which can reach 4 inches (10 cm) in diameter, has decurrent gills that run down along its stem, often taking on a pinkish coloration with age. In its youth, the cap is convex, then tends to flatten out as it matures, not infrequently developing a depression in the center. The cap has a consistency similar to suede; it's usually dry but tends to become sticky in humid environments.

Thanks to its flavor and unique smell, the *Clitopilus prunulus* is a sought-after species by mushroom foragers and those looking for stratified aromas. Though highly regarded gastronomically, it can be confused with poisonous species such as the *Clitocybe rivulosa*—a mycete whose Italian name denotes its toxicity: *imbuto del folle* (fool's funnel)—though this toxic species usually prefers ventilated meadows and lacks the characteristic pink spores and unmistakable bread dough smell.

DELICIOUS FUNGI

GRIFOLA FRONDOSA

HEN-OF-THE-WOOD OR MAITAKE

A saprophyte (meaning parasitic) fungus, it causes the death of the trees it colonizes, particularly chestnuts and turkey oaks. This highly prized, delicious mushroom with endless names is studied for its medicinal potential.

The scientific name captures its appearance: the *Grifola* is *frondosa*, or formed by numerous regularly stacked, fan-shaped "fronds" attached to a single stump. To the touch, it's slightly fibrillous and velvety. The speckled fronds, which range from whitish to nut-brown, resemble a host of small feathers, and its appearance can be reminiscent of the ruffled look of the most common barnyard animal, the hen, hence its name hen-of-the-wood. Restoring its nobility, on the other hand, are the names by which it's known in other cultures: in Italy, it's called the griffon or royal mushroom; in China, the ash flower; while in Japan, it goes by *maitake*, meaning "dance of the mushroom." According to a Japanese legend, in fact, those who encountered the fungus couldn't help dancing with joy for the gift fate had reserved them.

 One of the most curious autumn mycetes you can encounter in and around hillside oak groves, the *Grifola frondosa* usually latches on to adult trees, continues bearing fruit even when its tree is cut and until the trunk on which it's grafted is completely dead, and continues to grow back, year after year, in the same spot. Foragers who find one have an inexhaustible treasure to be jealously protected across the generations, like a precious family secret.

 The extremely pleasant smell, similar to toasted hazelnut, and the sweet flavor of its white flesh that stands up to cooking, make it the perfect mushroom for long-term conservation, and it's particularly popular preserved in oil.

DELICIOUS FUNGI

FISTULINA HEPATICA

OX TONGUE OR BEEFSTEAK POLYPORE

This polypore has a soft but tough consistency and a color ranging from brick red to purplish. Quite similar to a slice of meat, you might say? Perhaps that's why in Britain they call it the beefsteak polypore. When it's fresh, it even "bleeds" a reddish juice.

The ox tongue or liver mushroom, as they call the *Fistulina hepatica* in Italy, is the only polypore that can be eaten raw. It grows mainly on the trunks of oaks and chestnuts. Its cap, which can extend up to 9.8 inches (25 cm), is fleshy with an undulated edge. It almost always displays an irregular surface, popping off the tree trunk just as a giant tongue would. On the lower part are the small pores, which the fungus uses to release its spores. The *F. hepatica* is found in temperate regions, particularly in Europe, North America, and Australia.

Particularly curious is this mushroom's capacity to absorb the excess iron from the trunks on which it grows, the reason for which it takes on a bloodred color. Wood inhabited by this mycete is highly sought after in cabinetmaking due to its unique tone. The ox tongue is a saprophyte fungus that feeds on dying organic matter, thus playing an important ecological role in the forest's regeneration. Its presence is thus an indicator of a healthy wooded environment.

Not only does *F. hepatica* look like meat, it also tastes like it. Personally, it's the most convincing example of nonmeat "meat" I've ever tasted. So it's no coincidence that it's used in vegetarian recipes precisely as an alternative to meat, while in the past it was even employed to acidify milk; the presence of acetic acid, in fact, gives it a certain citrus-like aroma.

CRATERELLUS CORNUCOPIOIDES

BLACK TRUMPET OR HORN OF PLENTY

The black trumpet belongs to the Cantharellaceae family, those mushrooms that resemble small cups or tiny cornucopias.

The *Craterellus cornucopioides* is easily recognizable, thanks to its typical trumpet shape and funereal color, midway between gray and black. Some say it actually owes its popular name not to those grim tones but rather to the belief that it sprouts around November 2, or All Souls Day. It tends to grow in large groups in shady, damp areas, often in forests of broadleaf trees such as oaks and beeches, particularly near decaying stumps, between the rotting leaves and walls of moss. Between its appearance and the dark places in which it opts to sprout, the black trumpet is difficult to spot, but once you do, it's often present in abundance. Let's pick one: it can reach 4 inches (10 cm) in diameter, and it's characterized by a concave shape that deepens to form a spiral-shaped cavity. It has a wrinkled, coarse outer surface, while the inside is smooth and lighter, with its spores a pale yellow.

The *C. cornucopioides* has a mycelium known for its ability to form mycorrhizal symbioses with various trees, giving it a leading role in the invisible symbiotic network that keeps forests alive, producing beneficial effects both for the fungi and for the plants with which they come into contact.

Prized in the kitchen for its delicate, slightly fruity flavor, the aroma of the black trumpet recalls that of the porcino. The black trumpet is an ingredient in many traditional recipes, especially in France and Italy, where these mushrooms appear in risottos and pasta sauces. Its flavor and odor are reminiscent of the pungency of the truffle, making it an excellent substitute.

CALOCYBE GAMBOSA

ST. GEORGE'S MUSHROOM

Known as the St. George's mushroom (*prugnolo* or *marzolino* in Italy), it's prized for its delicate flavor and tender consistency.

Unlike many others, this mushroom speaks of spring: traditionally, in fact, it's said to mature on April 23—St. George's Day. In reality, the St. George's mushroom sometimes emerges as early as late March, depending on weather conditions, making it one of the first edible mycetes to appear after winter. It grows mainly in and around meadows and pastures, often amid thorny bushes such as the hawthorn, juniper, or blackthorn. It often appears in groups that form slightly hypnotic rings known as fairy circles—a peculiarity that has contributed to creating an aura around this mushroom in popular folklore. The St. George's mushroom is easily recognizable thanks to its convex or slightly flattened cap. It is cream-white in color (sometimes tending toward nut-brown). It can reach 4 to 6 inches (10 to 15 cm) in diameter and has a smooth and dry surface with slightly involuted edges. Its gills are dense, thin, and blended toward the stem, the same color as the cuticle.

From the ecological standpoint, the *Calocybe gambosa* plays an important role in the decomposition of organic matter, contributing to the fertility of the soil in which it grows. In fact, it's an important indicator of environmental conditions, in addition to being a key figure in the nutrient cycle in the meadows and woods where it proliferates.

It's highly regarded in the kitchen, both for its versatility and for its delicateness. It's wonderful both raw—thinly sliced and served as a salad—and cooked: perfect to give a sweet, floury dusting to risottos, omelets, and tagliatelle.

DELICIOUS FUNGI

LECCINUM AURANTIACUM

LITTLE OAK PORCINO OR ORANGE BOLETE

This mushroom belongs to the Boletaceae family and offers foragers the opportunity for a harvest that's sustainable and respectful of the environment.

It grows during summer and autumn in mixed and broadleaf forests and is often associated with birches, hence one of its popular names, birch boletus. It's most frequently encountered in moist and acidic soils, where it forms a symbiotic relationship with the tree roots, helping them absorb nutrients from the soil. Its distinctive cap varies from brown to rustred and presents a rough or scaly surface and a size that can vary significantly, reaching a diameter as large as 7.8 inches (20 cm). Another unique characteristic of the *Leccinum aurantiacum* is its long, robust stem, whose surface is covered with flakes and black dots, a detail that makes it easily recognizable among other mushrooms of the same family.

One of the most interesting aspects of the little oak porcino is its ability to adapt to various forest environments, showing a notable resilience to climactic and environmental variations, which makes it a useful indicator of the health of the broader ecosystem.

While the Orange boletes species have different scientific names depending on their host tree (*Leccinum versipelle* for birch trees, for example), they all have similar characteristics and can be safely eaten when thoroughly cooked. From the culinary standpoint, the *L. aurantiacum* has a delicate flavor and compact consistency that makes it suitable for various preparations, such as stews, risottos, or simply sautéed in the pan. After it's cut, the white flesh veers toward gray. It's tender in the cap and tough in the stem (which is often discarded). When cooked, the pulp becomes compact, slightly crunchy, and quite dark in color, providing a unique touch to mushroom soups.

DELICIOUS FUNGI

MACROLEPIOTA PROCERA

PARASOL MUSHROOM

Known in Italy as the drumstick, in English-speaking countries, it's called the parasol mushroom. While highly regarded everywhere for its taste, beware of dangerous look-alikes.

Common in Europe and North America, the parasol mushroom can pop up anywhere the soil is well drained: you find it both in pastures and in broadleaf and coniferous forests . . . and it's good at being noticed—the *Macrolepiota procera* is a truly imposing mushroom, capable of reaching a height of 19.6 inches (50 cm). Its stem, thin and fibrous, presents a characteristic scale motif reminiscent of a snakeskin. When it's still young, the cap is compact and egg shaped, though it smooths out as the mushroom matures, becoming almost flat with a dark bump in the center. The gills are dense and white, sometimes veined with a slight pink shade.

Recognizable though it may be, the parasol mushroom strongly resembles certain toxic mushrooms, like the *Chlorophyllum rhacodes*, whose stem lacks the snakeskin motif and can cause gastrointestinal ailments. Another false friend, responsible for many poisonings in North America and increasingly common in Europe, too, is the *Chlorophyllum molybdites*, which has gills that produce spores tending toward green and which also lacks the snakeskin pattern. Harvesting the parasol mushroom requires caution: if you find it, take a good look at the stem's characteristics.

Esteemed in the kitchen for its size and versatility, the parasol mushroom is particularly popular in the United Kingdom, where it's often sautéed in crackling butter, breaded like a cutlet, or used in recipes in which the caps are stuffed and the stem and bulb discarded, though some dry the latter and grind them up for soups, stews, and sauces. In truth, even the cap, to be considered edible, needs to be well cooked, and some people advise against grilling them.

DELICIOUS FUNGI

USTILAGO MAYDIS

CORN SMUT

The galls that the fruit of this fungus create on corn ooze a blackish liquid that, at first glance, isn't particularly appetizing.

Commonly known as corn smut, this fungus is clearly a parasite of the plant; indeed, when it develops, it creates large galls on the otherwise golden ears that can produce up to twenty-five billion spores each. Despite being a plant disease, in Mexico, *Ustilago maydis* is considered a genuine delicacy, *huitlacoche*. It's mainly eaten fresh but sometimes canned and can be found in restaurants and at street markets. Corn farmers sometimes intentionally spread its spores in the attempt to cultivate more fungi.

In Mexico, the consumption of corn smut is directly linked to Aztec cuisine. Ideally, to eat it, you gather the galls while they're still young, since as they mature they dry out and fill with spores. Young galls, harvested two or three weeks after the ear of corn is infected, actually maintain significant moisture and, once cooked, have a sweet flavor with woody and earthy notes. To make them more attractive in the eyes of English-speaking consumers, clever Central American vendors have rebranded them "Mexican truffles."

To develop, the fungus infects all parts of the host plant, invading the ovaries and causing the corn kernels to swell in tumoral bubbles. The galls are composed of hypertrophic cells of the infested plant, fungal filaments, and blue-blackish spores that give the corn a burnt, blackened appearance. The name *ustilago*, from the Latin *ustilare*, meaning "to burn," refers precisely to this feature.

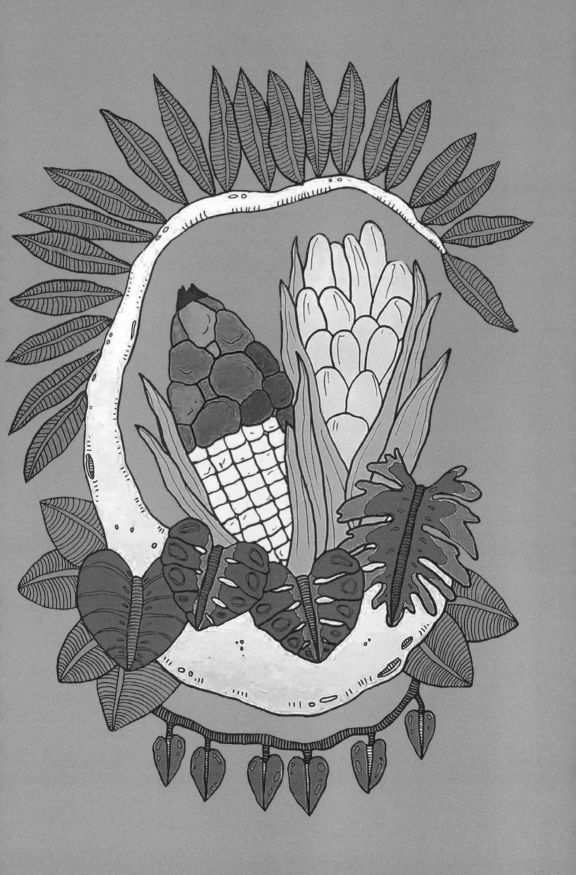

FUN FACTS ABOUT FUNGI

WHITE TRUFFLE FAIR IN ALBA, ITALY

Every autumn, in Piedmont's Langhe region, there's a huge fair dedicated to one of the world's most sought-after delicacies: the white truffle. Among the stands, vendors treat these tubers like gold nuggets, removing them from glass display cases, weighing them on precision scales, maybe even letting you get a whiff of their aroma if they think you're serious about buying. . . .

VISIONARY FUNGI

For millennia, visionary mushrooms have been at the center of rituals that represent the heart of entire cultural systems. Experiencing the ceremonies that use them becomes part of a symbolic coalescence that not only defines a group's identity but can improve individual participants' psychological state. Recently, these mushrooms have been the focus of discoveries that bear witness to their important therapeutic value.

VISIONARY FUNGI

AMANITA MUSCARIA

FLY AGARIC

This is the mushroom par excellence, but it's still mistakenly accused of being lethal. Its vast cultural impact, on the other hand, is partly unacknowledged: did you know, for example, that it plays an important role in the legend of Santa Claus?

Widespread in temperate and boreal regions, it grows in symbiosis with deciduous and coniferous trees. This iconic mushroom is celebrated in various cultures and is at the center of religious rites in various parts of the world. The fruiting bodies of the *Amanita muscaria* emerge from the soil like white eggs; the red cap appears as it matures through the veil, speckled with white warts, and its stem has a skirt. It's known as the fly agaric, due to the belief that putting some chopped-up pieces of it in a bowl with milk suffices to kill the insects. All varieties of *A. muscaria* also possess visionary properties, due to the psychoactive principles in muscimol and ibotenic acid. When boiled, the effect of these substances is reduced, and, in fact, the *A. muscaria* is eaten cooked in certain parts of Europe, Asia, and North America.

This mushroom also has a central role in Siberian shamanic culture. In Lapland, the shamans traveled to their followers on sleds pulled by reindeer, and legend has it that they avoided the snow piled before main entrances by entering through chimneys. Sound familiar? And that's not all: before entering others' houses, the shaman would eat pieces of *A. muscaria*. According to Sami tradition, anyone who ingests one of these mushrooms ends up resembling it, becoming rotund, red cheeked, and dotted with white details.

VISIONARY FUNGI

PSILOCYBE MEXICANA

MAGIC MUSHROOMS

When ingested, these mushrooms have a hallucinogenic effect on conscious experience: surfaces begin to undulate, sounds and colors intensify, objects move and trace tails of light through the air. Dream and reality merge through the mushrooms' psychedelic power.

The Aztecs called magic mushrooms *teonanácatl*, or meat of the gods, a significant name that forces us to look back in time. Knowledge of the properties of mushrooms containing psilocybin, in fact, can be found in various ages and in distant cultures, thanks to the diffusion of the mycetes of the *Psilocybe* genus, which numbers hundreds of species, spread almost everywhere. The first evidence takes us to seven thousand years ago and the rock illustrations from a cave in Tassili n'Ajjer, in Algeria, that portray priests with magic mushrooms in their hands. From a thousand years later is the mural of Selva Pascuala, inside a cave in Villar del Humo, Spain: the oldest European testimony of the use of psychedelic mushrooms. Archaeological remains of "fungal stones," on the other hand, tell of the presence of a sophisticated mushroom cult in 1500 B.C. Guatemala, while the Mayan statues depicting deities fused to the body of the *Psilocybe Mexicana* date to 1000 B.C. And it's thanks to this variety that, in the 1950s, "shrooms" gained popularity in the West, through the photo essay "Seeking the Magic Mushroom," which appeared in a May 1957 issue of *Life* magazine. In the article, R. Gordon Wasson recounts his experience with the "meat of the gods" in Huautla de Jiménez, in southern Mexico. His source was María Sabina, a folk healer and poet born in 1894 in the Sierra Mazateca who was a devotee from a young age to the celebration of the *veladas*, psilocybin-based nocturnal ceremonies, during which she sang while being transported on a journey to the edges of the universe.

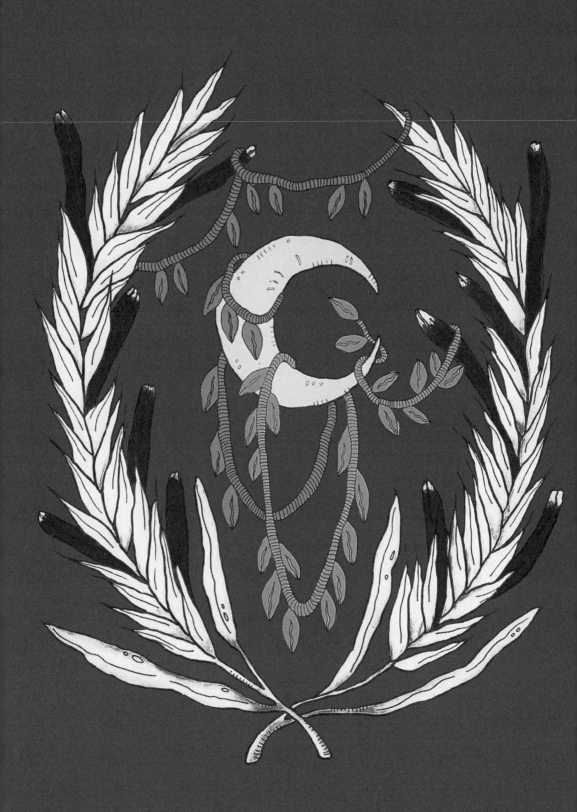

VISIONARY FUNGI

CLAVICEPS PURPUREA

ERGOT

Ergot is a fungus shaped like a black horn that grows on various cereals, especially rye, which is referred to as "horned" when infested. In the past, it caused epidemics of ergotism. In 1938, by synthesizing ergot's alkaloids, Albert Hofmann invented LSD.

Once, when a rye harvest was infested with *Claviceps purpurea*—a visible fungus, with its fruiting bodies easy to spot amid the ears of grain—it wasn't discarded, and when the rye was ground into flour, the resultant bread could appear bluish in color. It was a different time, when no harvest could be thrown away, even if the populations of central and northern Europe risked suffering consequences, which ranged from the disconcerting to the dangerous. Epidemics of ergotism were frequent: in some cases, the people affected by the disease, which inevitably assumed the proportions of a small epidemic—seeing as a mill was shared by a whole village—simply suffered from delirium for several days, but the most serious cases could lead to gangrene. Ergotism is also known as St. Anthony's fire due to the intense burning sensation of extremities and after the order of the Monks of St. Anthony, who were more skilled at treating the condition. Some theorize that those traveling to St. Anthony's were cured of their symptoms because the pilgrims began consuming wheat bread, which was more popular than rye in the region and which the ergot rarely attacked.

One of ergot's active principles, ergotamine, has been used since the 1920s to treat migraines. In 1938, the young Swiss chemist Albert Hofmann was asked by pharmaceutical company Sandoz Laboratories to investigate the effects of the other alkaloids present in the fungus, with the goal of verifying their potential in controlling the blood flow of women in labor. So it was that Hofmann, synthesizing the alkaloids present in horned rye, conducted experiments that led to his encounter with lysergic acid diethylamide, or LSD.

VISIONARY FUNGI

GYMNOPILUS JUNONIUS

LAUGHING GYM

After eating a handful, one woman exclaimed: "I'm dying, it's so much fun." Someone else replied, laughing: "If this is getting poisoned by mushrooms, I'm all for it." So it's no coincidence that its common name is the "laughing gym."

The *Gymnopilus junonius* is a large mushroom ranging in color from bright yellow to reddish brown, with gills that extend along the stem and a very visible veil. Its fruiting bodies can contain psilocybin—which is true for at least fourteen types in the *Gymnopilus* genus—and other compounds, like the alpha-pyrones present in kava (a shrub native to the western Pacific), whose ingestion can cause uncontrolled laughter, though this can alternate with nausea, stupefaction, hyperproduction of urine, and dizziness. In any case, these mycetes have an extremely bitter taste, which usually discourages their recreational use.

The laughing gym belongs to the vast genus of *Gymnopilus*, which numbers over two hundred species with rust-colored spores. Most of these varieties grow on wood, but some can proliferate on the ground, as well, near rotting stumps. Because they grow in different environments and resemble other mushrooms, precise identification is necessary; indeed, it's easy to confuse mushrooms from the *Gymnopilus* genus with those of other genera, like the *Pholiota* and the *Cortinarius*. Beginning foragers can also confuse *Gymnopilus* with mushrooms from the *Galerina* group, which include lethal varieties. Yet there are those who eat them: in Uruguay, for example, where the laughing gym is considered edible and is actually one of the most popular types, it's boiled to eliminate the bitter taste and then used in sandwiches with pieces of beef, bacon, and other ingredients.

VISIONARY FUNGI

PANAEOLUS FOENISECII

BROWN HAY OR MOWER'S MUSHROOM

The brown hay mushroom is small and extraordinarily resilient, and, as it grows in gardens, it may offer a first, bland visionary experience to beginners and, possibly, even dogs.

Also commonly known as the haymaker mushroom, the *Panaeolus foenisecii* is recognizable thanks to its small, convex cap ranging from light to dark brown and with a maximum diameter of 1.2 inches (3 cm). The thin, dense gills culminate in a slender stem of the same tone as the cap, perhaps slightly lighter. Another distinctive characteristic is the production of very dark spores. The haymaker adapts very well to meadows and gardens, particularly when the grass is freshly cut—a phenomenon that seems to stimulate its fructification and that has earned its popular name of mower's mushroom. It favors temperate climates and develops from spring to autumn. This mushroom displays impressive resilience, prospering in unfavorable conditions. Its ability to adapt has made it an object of study due to its capacity to survive in urban and suburban environments, offering information on fungal biodiversity and urban ecology.

Although it's often the mushroom closest to home and thus the most commonly ingested by dogs and children, the brown hay mushroom isn't considered edible, mainly due to its small size and lack of significant nutritional value. But it does contain something interesting: its active principles include derivatives of tryptamine and traces of psilocybin, which, even in small doses, can have some effect on curious dogs and children, though the "trips" are decidedly mild.

VISIONARY FUNGI

PLUTEUS SALICINUS

WILLOW SHIELD

The willow shield is a small, elegant hallucinogenic mushroom that grows directly on the wood of certain trees.

Hidden in the underbrush, the willow shield intrigues with its colors varying from brown to purplish and a cap that, displaying softer tones in its center, turns from campanulate to flattened as it matures, developing a slightly viscous surface. Its elegance comes through in gills that start out pure white but are tinged with pink over time. It grows on decaying wood, especially alders and willows, from which it gets its name. The robust cylindrical stem can reach 4 inches (10 cm) in height, with a coloration similar to the cap. Partial to aging willows, on which it stands with its cylindrical and resistant stem, this mushroom has no ring, an exception in the *Pluteus* genus. It appears between late spring and autumn, proliferating in moist and shady corners and niches. Its distribution and adaptability are quite extensive, ranging from Europe to North America.

The most significant feature of the willow shield, however, may be the series of psychoactive principles it contains, starting with psilocybin and psilocin. These tryptamines, though present in smaller doses than in other mushrooms—such as those of the *Psilocybe* genus—can induce sensory and synesthetic alterations upon ingestion. Such alkaloids, moreover, have long been the object of scientific study due to their potential therapeutic qualities, which range from the possible treatment of clinical depression to that of addictions and anxiety.

VISIONARY FUNGI

INOCYBE AERUGINASCENS

GREEN-FLUSH FIBERCAP

The green-flush fibercap is a small mushroom capable of inducing visionary experiences that, apparently, are always euphoric.

Long unnoticed, this small mushroom appearing between late spring and autumn in the meadows of central Europe owes its common name to its small greenish cap, which flattens out over time from its original conical shape, helping it to camouflage itself among the broadleaf and coniferous trees. Preferring temperate climes, it can be identified thanks to its gills, which veer from snow-white to brown as the spores mature, as well as by its thin stem, of a color similar to the cap.

What make it interesting, however, are the psychedelic horizons it's capable of revealing. It attracted the attention of mycologists in the early 1980s when there were some cases of intoxication in Germany following accidental ingestion. Upon closer examination, it was discovered that, in addition to psilocybin and psilocin, the mushroom contained traces of baeocystin and aeruginascin, a previously unknown alkaloid that took its name. The "trip" set off by this mushroom presents peculiar characteristics: people have recorded impressions of decreasing gravity, colorful hallucinations, and spatial illusions, and a German mycologist described the presence of vivid abstractions, as well as the sensation of perceiving his soul in flight. All cases of intoxication by *Inocybe aeruginascens* have induced significant sensations of euphoria. The consumption of the greenish fibercap is, by and large, safe; more problematic, if anything, is its correct identification, since it bears a close resemblance to dangerous species.

VISIONARY FUNGI

CONOCYBE SILIGINEOIDES

MAGIC CONE CAP, YA'NTE, TA'A'YA, OR TAMU

Known as the magic cone cap, this little mushroom was used in shamanic rituals by the Mazatec in the Oaxaca region of Mexico.

The name *Conocybe* derives from the ancient Greek *cono*, or "cone," while *cybe* means "head." The *Conocybe* genus of fungi is a numerous one, comprising at least 243 species.

The magic cone cap stands out, thanks to its small bell-shaped cap, with a maximum diameter of 1 inch (2.5 cm). It has a smooth surface and a color oscillating between light brown and nut-brown, slightly darker at the center. This little magic mushroom has dense gills, initially pale in color but which darken as the spores mature, while its stem, which can reach a height of 2.3 inches (6 cm), is thin, fragile, and pale in color. It grows in moist and shady environments, on ground rich in rotting wood and woodchips, such as abandoned gardens or, naturally, forests. It appears mainly between late spring and autumn.

This tiny mushroom contains two well-known psychoactive compounds, psilocybin and psilocin, capable of triggering psychedelic experiences. The presence of these alkaloids classifies the *Conocybe siligineoides* in the family of sacred mushrooms, and its use in the sacred rituals of the Mazatec is no coincidence. Despite its qualities, it's important to remember that consuming this mushroom has a notable degree of risk for inexperienced foragers, due to its close resemblance to highly poisonous species. One of its "cousins," the *Conocybe filaris*, is a common meadow mushroom that contains the same lethal toxins as the far better-known *Amanita phalloides*.

VISIONARY FUNGI

AMANITA PANTHERINA

PANTHER CAP

According to the testimony of some Ajumawi elders—a tribe that lives in northern California—in ancient times, shamans ate this mushroom during curative ceremonies for the purpose of seeing the patient's spirit, with clairvoyant effects.

The Native American Ajumawi, who live in the Fall River Valley and belong to the Pit River ethnic group, preserve testimony of a traditional use of the *Amanita pantherine*—a unique occurrence, seeing as it's the only ethnographic case in the world of using this mushroom species, possessing psychoactive properties similar to those of the *Amanita muscaria*. The Ajumawi call this mushroom the *pulqui* and believe that it's born after the thunder and lightning of spring storms. Those intending to gather it head into the forest chanting to arouse its attention, addressing prayers to the mushroom, the thunder, and the lightning. These mushrooms are picked only in spring, when the violets and dogwood bloom. When they're picked, a large white feather is waved back and forth over the pulqui. Once they've been dried, the mushrooms are placed in a leather container until the time comes to use them. The pulqui are used for curative purposes even today, sometimes in place of peyote. Given the variability of their potential results, the mushrooms are ingested gradually, until the onset of the sought-after effects.

 The *A. pantherina* is a wild mushroom known for its psychotropic qualities, and it's renowned for its powerful, sometimes dangerous effects. It can be found in Europe, North America, and Asia, often in spring and autumn. It contains alkaloids, like ibotenic acid and muscimol, which can cause hallucinations and alterations of perception. Symptoms can include euphoria, visual and auditory distortions, and, in serious cases, convulsions. Consumption of this *Amanita* is dangerous in inexperienced hands.

MARÍA SABINA

The folk healer par excellence, she was a veritable shaman who achieved legendary status in Mexico. Ever since childhood, María Sabina, born in the remote Oaxaca region, wandered in and around her village gathering her *niños*, the magic mushrooms she would use to conduct sacred ceremonies throughout her life.

POISONOUS FUNGI

It's such common knowledge that saying it may serve no purpose, and yet—given the articles in the local news come each autumn—perhaps it does. Many mushrooms are poisonous, and many of these are easily confused with others that are wonderfully edible. The most lethal mushroom of all, *Amanita phalloides*, is, in fact, a close relation to one of the most delicious, *Amanita caesarea*. It's worth remembering that the information contained in this book serves as a general indication and is not exhaustive.

POISONOUS FUNGI

AMANITA PHALLOIDES

DEATH CAP

This mushroom's popular nickname of "death cap" makes reference to its lethal toxicity.

Seeing as it's practically dangerous just to look at, it's worth describing. The death cap, with a diameter between 2 and 6 inches (5 and 15 cm), starts out as a tiny globe that tends to flatten out as it matures. It presents a smooth surface ranging from olive green to brownish yellow, often with paler tones toward the edges, and its gills are free, dense, and white. The stem, up to 6 inches (15 cm) tall, is robust with a prominent ring and has an enlarged base surrounded by a volva, an important distinctive trait. It favors broadleaf and coniferous forests, often growing near oaks, chestnuts, and pines. Native to Europe and Asia, it was unintentionally introduced and can now be found in North America and Australia as well.

The death cap contains deadly toxins such as alpha-amanitin and phalloidin, which cause serious liver and kidney damage, leading to hepatic failure and death. These substances inhibit an enzyme crucial to the synthesis of RNA, thus blocking this vital cell function. The toxic effects aren't immediate but usually appear after a latency period that can vary from six to twenty-four hours from ingestion, a delay that often makes treatment impossible. Symptoms of poisoning can include vomiting, diarrhea, cramps, and grave dehydration.

The *Amanita phalloides* can also be mistaken for edible mushrooms, making its identification a difficult task for nonexperts: mycetes it resembles include mushrooms from the *Agaricus* group, the *Amanita ovoidea*, and the *Amanita rubescens*.

POISONOUS FUNGI

COCCIDIOIDES IMMITIS

VALLEY FEVER FUNGUS

A microscopic fungus that causes valley fever
(or coccidioidomycosis), an infection
that can become quite serious.

Coccidioides immitis is a dimorphic fungus, meaning it can exist both as a mold in the soil (around 77°F/25°C) or as yeast in a host body (at more or less 98.5°F/37°C). The little fungus, which behaves, for all intents and purposes, like a pathogen, dwells in the soil of certain desert areas such as the southwest United States, northern Mexico, and some regions of Central and South America. It generally grows in the ground, but under certain conditions—when the spores are shaken up by the wind or activities like agriculture and construction work—it spreads, becoming inhalable by humans and animals. When breathed in, *C. immitis* can trigger coccidioidomycosis, a lung disease that varies from mild forms similar to the flu to potentially lethal infections. Once the spores reach the lungs, they can turn into the yeast form of the fungus, which replicates, causing sickness.

 Even if most people recover without specific treatment, in some cases the infection can spread to other parts of the body, becoming more serious. The disease's symptoms appear from a week to over a month after contact with the spores and can include coughing, fever, muscle pain, and fatigue. If the infection spreads beyond the lungs, it can involve the skin, bones, nervous system, and other organs. In certain cases, the pathology causes a painful rash known as erythema nodosum. Prompt diagnosis and treatment are crucial, especially for individuals with a weaker immune system—the elderly or pregnant women—who are at greater risk of developing the more serious forms.

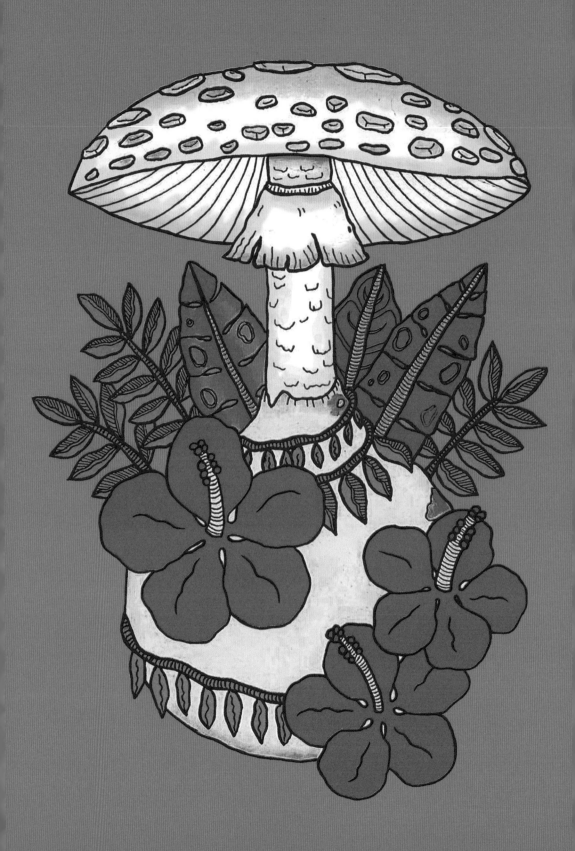

AMANITA VERNA

FOOL'S MUSHROOM OR SPRING DESTROYING ANGEL

Known as the fool's mushroom or spring destroying angel, it's one of the most dangerous mushrooms in part because it's often confused with others that are perfectly edible.

The fool's mushroom, part of the Amanitaceae family, is characterized by a white cap devoid of scales or striations and a thin stem with a ring and volva. The latter is a membranous residue that wraps around the base of the stem early in the fungus's life cycle and is shaped like a small, nearly spherical sac. In the fool's mushroom, the volva is entirely underground, a detail that can trick amateur foragers who cut the mycete at the point where it emerges from the soil, often not seeing the volva at all.

Poisoning by *Amanita verna* is due to amanitin, a class of toxins that seriously harm the liver, kidneys, and other vital organs, interfering with the cellular process and causing irreparable damage. Symptoms don't appear immediately: the first stages can be asymptomatic or characterized by ailments such as nausea, vomiting, and diarrhea, but degeneration is rapid and damages not only organs but the central nervous system, as well. Prompt diagnosis is crucial, as is medical support, because some cases require a liver transplant to save the patient's life.

The fool's mushroom grows in broadleaf and coniferous forests, especially in spring and summer, and is widespread in various temperate regions. Its area of distribution contributes to cases of mistaken identification: notable are its resemblance to the *Amanita virosa*—the spring *ovolo*—an inedible mushroom that shares many characteristics with the *A. verna,* such as the white cap and the thin stem with ring and volva. Another source of confusion is the *Agaricus campestris*—the meadow mushroom—absolutely edible, very common, and "cousin" of the champignon.

POISONOUS FUNGI

OMPHALOTUS OLEARIUS

OLIVE MUSHROOM

The olive mushroom is such a convincing imitation of chanterelles that it's responsible for the majority of mushroom poisonings in the Mediterranean.

The olive mushroom displays cespitose growth, meaning on stumps, roots, or the rotting wood of olive trees, oleasters, holly oaks, and shrubs such as rock rose and mastic. It's a lignicolous fungus, breaking down rotting organic matter, and is quite widespread among Mediterranean shrubs.

The *Omphalotus olearius* is highly toxic and can rapidly induce a potentially serious gastrointestinal syndrome. In appearance, it resembles a small funnel with a bright-orange coloration that, when touched, stains your fingers orange: an indicator to keep firmly in mind (and to which it owes one of its nicknames: lacquered mushroom). Another clue to remember is its pale-green bioluminescence: in the dark, in fact, its gills emanate a dim but fascinating light, a curious characteristic to which the mycete owes another of its popular handles: the ghost mushroom.

The olive mushroom belongs to the Marasmiaceae family and has a fleshy cap and robust gills. Its stem is solid, fibrous, and usually curved. Despite its two notable distinctive characteristics, to the untrained eye, it can appear deceivingly similar to the delicious chanterelle, which is why it's often picked, a mistake that, in certain cases, can be dangerous—partly because chanterelles, of course, are eaten in large quantities.

POISONOUS FUNGI

RUBROBOLETUS SATANAS

SATAN'S BOLETE

Sublime in its ominous aura of evil, and known as Satan's bolete, this cousin of the king of the woods is decidedly toxic.

It looks straight out of a comic in which it plays the bad porcino to perfection, and, indeed, Satan's bolete is a poisonous mushroom belonging to the family of the Boletaceae, with morphological characteristics that convey its dangerous true nature. The *Rubroboletus satanas* is a poisonous mushroom with a large, brick-red cap and spongy orangish-red tubules that when bruised turn green. As if that weren't enough, once cut, its flesh is blue, while its stem is red in the upper part and gradually whitens toward the base. It has an unpleasant smell, nauseating after awhile, and when it matures, it stinks like a corpse. Its initial flavor is reminiscent of a sweetish walnut, but it soon becomes revolting. The Satan's bolete grows in forests during summer and autumn, and amateur foragers can mistake it for its delectable cousins, perhaps mainly when the cap lightens in color, after contact with a leaf, becoming white—a dynamic common to all boletes. It must be said, however, that, to make that mistake, you'd need to disregard all the other danger indicators that the mushroom presents.

Regardless, it's important not to mistake it, not to pick it, and, obviously, not to serve it in a salad, because Satan's bolete contains toxins that can cause serious gastrointestinal problems, such as lengthy and exhausting vomiting. Making it poisonous is bolesatine, a toxin known to cause a certain number of poisonings among particularly inexperienced foragers. But, really, what more does it have to do to persuade you to ignore it and move on?

POISONOUS FUNGI

GYROMITRA ESCULENTA

FALSE MOREL

A mushroom with a curious brain shape, it's seemingly delicious but, under certain conditions, can be deadly.

Known as the false morel, this mycete belongs to the Discinaceae family and attracts attention due to both its taste and its toxicity. Recognizable particularly due to its lobed cap, with sinuous, highly irregular ribbing, its color ranges from brown to gray or brick red, and it has a short, curved stem connected to the lower part of the cap. It fructifies in spring in coniferous and broadleaf forests, near rotting tree stumps. Though potentially lethal, in some parts of the world it's eaten for its wonderful flavor; indeed, its toxicity varies, based on a series of factors. When eaten raw and in large quantities, it's deadly; it remains toxic when cooked, but its danger diminishes, such that in Finland it can even be purchased raw, dried, or canned, as long as warnings are included concerning its danger and providing instructions in case of poisoning.

The *Gyromitra esculenta* contains a large quantity of gyromitrin—a molecule composed of various types of hydrazine—which not only causes serious intoxication but is also carcinogenic. Poisoning by *G. esculenta* is called *Gyromitra* syndrome and has a long incubation period; its symptoms, including headaches and dizziness, can appear up to twelve hours after ingestion. These symptoms often regress, but in 15 percent of cases, after a few days, there can be potentially fatal problems with the kidneys or anemia. Eating it is like playing Russian roulette: there are threshold values that vary from one person to the next, beneath which the false morel apparently has no effect. But once they're exceeded, it becomes deadly.

POISONOUS FUNGI

CORTINARIUS ORELLANUS

FOOL'S WEBCAP

Long considered to be an edible mushroom, it turned out to be deadly following a mass poisoning that occurred in Poland.

Cortinarius orellanus is a poisonous mushroom belonging to the Cortinariaceae family. Today, we know it's highly toxic, but it's one of those mycetes that was long a subject of uncertainty. It was eaten quite regularly until, following a group intoxication that led to numerous deaths, its chemical profile was thoroughly studied, revealing its characteristic toxin—named orellanin—whose serious effects on the kidneys can appear as long as fourteen days after the meal. It's likely that this delay is what exonerated the little mushroom for decades, if not centuries. . . .

It has an almost humble appearance, as though it wishes to go unnoticed among the various little mushrooms of the forest floor: it has a campanulate cap of small to medium size, ranging from orange to brick red, whose surface is often covered by little scales or fibrils. The stem is relatively thin, with a coloration similar to the cap and a membranous ring, perhaps its most distinctive characteristic, toward the bottom. It grows in broadleaf and coniferous forests.

Its resemblance to various edible mushrooms makes it particularly dangerous for "Sunday morning" foragers, so it's crucial to be able to identify it precisely to avoid the risk of serious intoxications.

Symptoms of *C. orellanus* poisoning can include gastrointestinal discomfort, kidney failure, edema, hypertension, and other serious metabolic ailments. Orellanin is a non-thermolabile toxin, meaning it's resistant to cooking.

POISONOUS FUNGI

SCLERODERMA CITRINUM

COMMON EARTHBALL OR PIGSKIN POISON PUFFBALL

While inexperienced foragers have confused the *Scleroderma citrinum* with truffles, to know that it isn't, all you have to do is cut it in half and see it gleam like a crystal inside a dusty stone.

I'm not sure why people in the Castelli Romani area call this mushroom the wolf's chest, but what I do know is related to the scientific name in which *Scleroderma* converges from Greek and informs us of the firmness of the cuticle, while *citrinum*—"lemon," in Latin—is associated with its color. In English, on the other hand, it's known as the common earthball or pigskin poison puffball.

A representative of the Sclerodermataceae family, it begins its growth underground and only partially emerges from the soil, one reason for which—since its stem is invisible—it's sometimes mistaken for a truffle. The cap—or, in this case, the vesicle—has a globular shape and a color between lemon yellow and ocher. The surface, dotted with small warts that detach easily to release spores, is somewhat similar to a tennis ball. Quite widespread in forests, moors, and short grass, it grows during autumn and winter.

Scleroderma citrinum has firm, compact flesh that's dark and glossy, and as it ages, it tends to turn into a blackish dust. The exterior skin ends up breaking open to spread spores, releasing an odor similar to bad-smelling medicine. Ingesting *S. citrinum* can cause gastrointestinal ailments in both humans and animals and may lead to tearing, rhinitis, and rhinorrhea, while just being exposed to the spores can bring on conjunctivitis. Its danger varies from one mushroom to another and is influenced by environmental factors.

POISONOUS FUNGI

GALERINA MARGINATA

FUNERAL BELL

One of the most dangerous mushrooms, it combines toxicity with a resemblance to a wide range of perfectly edible and quite common species, from pioppino mushrooms to honey mushrooms.

Galerina marginata has a small conical or hemispherical cap with a diameter that's usually between 0.8 to 2 inches (2 to 5 cm). Its color oscillates among various shades of brown, often displaying a small protuberance at the center. The stem is tall, generally darker above and lighter below. Beneath the cap are dense gills, narrow and brown in color, which produce spores, themselves brown when they mature. The *G. marginata* grows in forests around the world, in groups of numerous individuals, often on decaying wood, especially that of conifers.

It's a potentially deadly mushroom because it contains amatoxin: there have been reports of serious intoxications and "para-phalloid" ailments upon ingestion—similar, that is, to those induced by the *Amanita phalloides*. The toxins present in the mushroom can cause liver damage, even liver failure. Often, after its ingestion and a first series of painful gastrointestinal symptoms, the person who ate the *G. marginata* undergoes a brief improvement in their condition, followed, however, by liver damage that can prove to be irreversible or, at any rate, lead to significant health complications.

FUN FACTS ABOUT FUNGI

R. GORDON WASSON AND VALENTINA PAVLOVNA

R. Gordon Wasson, an American banker and amateur mycologist, and his wife, Valentina Pavlovna, a Russian pediatrician specializing in mycology, have played a pioneering role in the field of ethnomycology, studying the traditional uses of many mushrooms. The couple is best known for documenting the ceremonies that María Sabina conducted in Mexico.

MEDICINAL FUNGI

The fact that at least one fungus, *Penicillium notatum*, made medical history is well-known: to it, we owe penicillin, in particular, and the class of antibiotics, more generally. What many people might not know is that there are a great deal of fungi with medicinal properties, sometimes opportunely exploited by age-old remedies but, more often than not, vastly understudied by Western pharmacology. Fortunately, things are finally changing.

MEDICINAL FUNGI

AGARICUS SUBRUFECENS

ALMOND MUSHROOM OR MUSHROOM OF THE SUN

Native to North America, it's commonly known as the almond mushroom, due to its aroma, but more interesting than these organoleptic notes is its therapeutic potential, long exploited in traditional medicine.

Agaricus subrufecens, a small mushroom that resembles a cappuccino with a dusting of cocoa on top, grows in temperate zones in both wooded areas and meadows, often close to decaying wood, and frequently in quite dense groups. From North America east of the Rocky Mountains, the almond mushroom has spread to other parts of the world as well.

Recent studies have shown how *A. subrufecens* contains compounds with potential health benefits, such as antioxidants and immunostimulants. In the world of medicinal fungi, the almond mushroom is also known as *Agaricus blazei*; in Brazil, where it's called the *cogumelo do sol* (mushroom of the sun), it's quite widespread and commonly commercialized for its curative properties; in Japan, where it's known as *himematsutake*, it's cultivated for medicinal purposes and is considered one of the most important species, combining therapeutic properties with the approval of gourmands. Traditionally used to treat diseases such as arteriosclerosis, hepatitis, diabetes, dermatitis, and cancer, it's included as a medicinal ingredient in various dietary supplements on the North American market, even though the Federal Drug Administration (FDA) has suggested caution in such uses and prohibits the inclusion of therapeutic properties on the label. For while there have been many studies on *A. subrufecens*, none have been conducted long-term or exclusively on human patients (at the moment, some of its virtues have only been proven on mice).

MEDICINAL FUNGI

PHELLINUS LINTEUS

MESHIMAKOBU, SONG GEN, OR SANGHWANG

Known in Japan as the *meshimakobu*, in China as the *song gen*, and in Korea as the *sanghwang*, this mushroom boasts a long history in traditional East Asian medical practices.

Phellinus linteus develops in the shape of small fans with a slightly knotty appearance and has a rather woody consistency. Its color, appearing in concentric bands, varies from dark brown to black, with a lighter, ocher-yellow edge that gives it a nice touch of elegance. It grows on broadleaf trees, often mulberry, apple, and pear, typically in ancient forests and other low-anthropization wooded environments. Native to various Asian regions, you can encounter it with a certain frequency in North America as well.

Though not an edible mushroom in the strictest sense, it provides extracts and is sometimes consumed as a powder. In traditional Asian medicine, *P. linteus* has long been a popular medicinal mushroom, widely used in China, Japan, and Korea, due to its various bioactive components, including polysaccharides, triterpenoids, phenylpropanoids, and furans. Various studies, particularly in Asia, claim that this mushroom possesses antitumoral, anti-inflammatory, immunomodulating, anti-oxidizing, and antimycotic properties, as well as antidiabetic, hepato-protective, and neuroprotective effects. At the moment, however, chronic toxicity data for the *P. linteus* is still lacking, and questions regarding its standardization according to the criteria of Western pharmacopeia remain unanswered.

MEDICINAL FUNGI

INONOTUS OBLIQUUS

CHAGA

A parasite of the birch tree, this mushroom, known as Chaga, is native to the world's cold northern regions, where it's highly valued for its outstanding medicinal qualities.

In his 1968 semiautobiographical novel, *Cancer Ward*, Nobel Prize winner Aleksandr Solzhenitsyn recounts how his tumor was cured thanks to a decoction of Chaga, after the official drug therapies of the time had failed. *Inonotus obliquus* is a fungus that, curiously, appears to be a carcinogenic parasite in its own right, like a burn or tar blister on birch trunks. It grows slowly and can reach significant size, partly because its development can last several years.

Long used as a popular medicine to treat degenerative illnesses like ulcers, gastritis, and tuberculosis, it's recognized today for its important therapeutic potential and its rich collection of active ingredients, including molecules like terpenes, peptides, sterols, polyphenols, and polysaccharides, all potential allies against cancer cells. For this reason, over the last ten years, the Chaga mushroom has been subjected to a series of tests in order to better evaluate its anticancer potential: the triterpenoid inotodiol, for example, has shown effects inhibiting carcinogenesis. And Chaga's polysaccharides have demonstrated potential antitumoral effects, both as antioxidants and as immunostimulants. There are various *I. obliquus*-based supplements on the market, generally presented as adjuvants to improve the functioning of the immune system. In Russia, Chaga is traditionally consumed in the form of tea or as an extract, often to treat stomach ailments or skin diseases.

MEDICINAL FUNGI

CANTHARELLUS CIBARIUS

CHANTERELLE OR GIROLLE

A famous, almost legendary, mushroom, the chanterelle (or girolle) is a gastronomic must with surprising therapeutic virtues.

Renowned for its bright yellow-orange color, an aroma reminiscent of apricots, and its trumpet-like shape, the chanterelle grows in broadleaf and coniferous forests, with a preference for moist, shaded soil, over most of Europe and in North America and Asia. Celebrated at the table for its slightly peppery flavor and fleshy consistency, it also proves quite versatile in the kitchen, good in both simple omelets and risottos and more elaborate recipes. Its Italian name, *finferlo*, likely derives from the old Germanic *Pfifferling*, alluding to a small, select mushroom.

What some people might not know is that *Cantharellus cibarius* is extremely rich in therapeutic properties, so rich that, on its own, it constitutes an excellent dietary supplement. Its small, golden body contains a treasure trove of highly useful vitamins, such as B and D; minerals like copper, iron, and potassium; and antioxidants. The latter, particularly, given their high concentration, can help offset the damage caused by free radicals, potentially reducing the risk of contracting chronic and cardiovascular ailments, as well as some types of cancer. Moreover, chanterelles contain significant amounts of polysaccharides, particularly beta-glucans, known for their immunomodulating properties, meaning they're able to stimulate the immune system, improving the body's response to infections. In short, girolles seem to be a genuine elixir of long life—no surprise given their wealth of active ingredients—though excessive consumption is not advised since they contain potential allergens.

MEDICINAL FUNGI

CORDYCEPS MILITARIS

CORDYCEPS

This little mushroom looks like a thin tongue of fire that, upon closer examination, rises from the chitinous carcass of an insect. As if that weren't enough, it contains a veritable pharmacopoeia.

It's small, slender, and bright orange, and it sinks its hyphae into the body of larvae and pupas of dead butterflies or moths, which it quickly empties out, leaving just the exoskeletons. This would more than suffice to make it an interesting mushroom, but the *Cordyceps militaris* also attracts mycologists' attention due to its elevated therapeutic properties. This peculiar mycete grows in various parts of the world and can be found in the moister environments of both European and North American forests, but it's in Asia that it's become famous.

In traditional Chinese medicine, *C. militaris* has been used for centuries to treat a wide range of pathologies, but it's also believed to possess properties capable of improving one's physical energy and endurance and to function as an aphrodisiac. Its consumption also seems to increase the production of adenosine triphosphate, the principal source of cellular energy, and improve the use of oxygen, two qualities that have made it quite popular among East Asian athletes. It has even been used to support the respiratory system, thanks to its anti-inflammatory and bronchodilatory properties, and the intestines. In Asia, some also believe it to have antitumoral effects. In this regard, several studies have shown how the presence of compounds like cordycepin—an enzyme characteristic of *C. militaris*, and from which it gets its name—have the ability to interfere with the metabolism of cancer cells, limiting their growth and spread.

MEDICINAL FUNGI

HERICIUM ERINACEUS

LION'S MANE

Magnificent and luxuriant (English-speaking countries call it lion's mane; in China, it's known as monkey's head), looking at this mushroom brings to mind the beard of an old god, which makes sense considering the powers it's capable of unleashing.

Hericium erinaceus is an edible mushroom equipped with astounding beneficial properties, and it is unique in appearance too: it resembles an orderly tangle of long, soft hanging spines, and its color can appear as various shades of cream. It grows spontaneously on dying broadleaf trunks, particularly oak and beech trees, in Europe, North America, and Asia, and it's valued in the kitchen due to its fleshy consistency and delicate flavor, with sweetish notes reminiscent of crustaceans. But it's in this chapter for other reasons: it's now universally prized for its neuro-protective properties, long familiar in traditional Chinese medicine.

This mycete, in fact, is rich in bioactive compounds like erinacines—metabolites that help recover from cognitive decline during aging. This discovery has made possible new therapeutic strategies in the prevention and treatment of dementia, including Alzheimer's. The consumption of lion's mane, commercialized in supplement form, also increases concentration, memory, and mental clarity. This medicinal fungus's other therapeutic properties include anti-inflammatory, immunomodulating, and antioxidizing effects, as well as potential benefits in the reduction of anxiety and depression. Lastly, there are even indications that *H. erinaceus* can improve gastrointestinal health, encouraging the proliferation of beneficial bacteria and providing relief from digestive ailments.

MEDICINAL FUNGI

GANODERMA LUCIDUM

REISHI

In Japan, it's call *reishi*, and in China, it's called *lingzhi*—two terms translatable as "divine mushroom," a nickname owing to the conviction that this mycete grants a longer life to those who eat it.

Reishi has a pretty, glossy cap (to which its scientific name alludes) that's semicircular in shape and, like many polypores, displays a banded coloration reminiscent of little rainbows, in this case oscillating among various shades of red, darker at the center and lighter toward the edges. Despite not being edible in the strictest sense of the term, due to the woody quality of its flesh, it is widely utilized in the form of extracts and powders. It grows on dying trees, particularly those of the broadleaf variety.

Originating in the wet and temperate regions of Asia, it's now cultivated in many parts of the world due to its renowned therapeutic properties. According to traditional Asian medicine, an infusion of reishi can help prevent a host of ailments: stomach ulcers, nosebleeds, loss of appetite, heart palpitations, hypertension, asthma, constipation, erectile dysfunction, tumors, and insomnia.

This mushroom continues to be valued as a strong immunomodulator, due to the presence of polysaccharides and triterpenes, compounds that support the immune system and have shown potential in inhibiting the growth of cancer cells. Moreover, the *Ganoderma lucidum* is used for its antioxidizing, anti-inflammatory, and tranquilizing properties, as well as to help manage stress, improve sleep quality, and increase a general sense of well-being. Certain research suggests that it may have beneficial effects on cardiovascular health, as well, reducing blood pressure and cholesterol levels. And as if that weren't enough, it is believed that hanging one on your front door will even ward off evil spirits!

MEDICINAL FUNGI

HYPSIZYGUS TESSELLATUS

SHIMEJI OR BEECH MUSHROOM

In East Asia, where it grows, this mushroom is called *buna-shimeji* and is widely used in cooking. But it's so rich in medicinal properties that talking about it only as a food would be reductive.

Hypsizygus tessellatus grows in thick clumps that display a myriad of caps ranging in color from white to light brown, like a celebration of little bubbles, and has a long, thin stem with dense, narrow gills that run from the cap to the mycete's base. It often flourishes on the trunks of broadleaf trees like oaks and chestnuts, both in the wild and in controlled cultivations.

In the kitchen, it should be cooked; it's prized for its delicate, vaguely hazelnutty flavor and crunchy consistency. From a nutritional standpoint, *H. tessellatus* is rich in protein, fiber, vitamins (particularly B and D), and minerals (especially potassium, zinc, and copper), characteristics that make it a very healthful food, suitable for a variety of diets. Group B vitamins, abundant in the buna-shimeji, are important for maintaining mental and cognitive health, but the entire set of nutrients in this little mushroom is essential for brain functioning and can help improve mood and reduce stress. Moreover, thanks to its high fiber content, *H. tessellatus* is beneficial to the digestive system, promoting intestinal regularity and preventing problems like constipation. Lastly, like many other mushrooms, the buna-shimeji contain antioxidants that help fight the damage caused by free radicals, which can have a positive impact in preventing chronic diseases. Not bad for a mushroom that isn't even traditionally considered to be medicinal. . . .

MEDICINAL FUNGI

LARICIFOMES OFFICINALIS

AGARIKON

Agarikon is a parasitic mycelium that grows in ancient coniferous forests, colonizing particularly old larches. Common along America's northwestern Pacific coast, it's becoming rarer elsewhere. Ever since ancient times, it has been numbered among the principal medicinal mushrooms.

Known since classical antiquity by its Greek name, this large mushroom reminiscent of an upside-down hat with yellow-grayish stripes has always been at the center of customs and cults of indigenous North American peoples. The native Tlingit, Haida, and Tsimshian tribes considered it important from a medical and spiritual viewpoint. In their rituals, they placed carved specimens of what they called ghost bread on shamans' tombs. The Haida, native to British Columbia, even identified in *Laricifomes officinalis* a deity called Fungus Man, to whom, according to the myth, we owe the existence of women and, therefore, humanity itself.

But the curative fame of the *L. officinalis* went far beyond North America: scientists claim that traces of agarikon were even found in the stomach of Ötzi, the ice mummy over five thousand years old who was discovered on Mt. Similaun, on the border between Italy and Austria. The botanist Pedanius Dioscorides in 65 A.D. documented the use of agarikon in ancient Greece, where it was used against tuberculosis. In the more recent past, this fungus was also known as quinine conk, since it was part of a decoction used against malaria (though it's no longer considered antimalarial). Mycologist Paul Stamets, moreover, has conducted various studies on the mushroom's antiviral qualities, demonstrating the effectiveness of its extracts against various viruses, including those from the smallpox, herpes, influenza A and B, and tuberculosis families.

MEDICINAL FUNGI

PENICILLIUM (GENUS)

PENICILLIUM

In 1928, pharmacologist Alexander Fleming discovered that *Penicillium notatum* was able to kill bacterial colonies of *Staphylococcus aureus*. It was a day that changed the history of medicine.

The genus *Penicillium*, known for the discovery of the antibiotic penicillin, is a quite common group of microscopic fungi that's important in both the medical and industrial field. The fungi are actually molds, easily recognizable for their characteristic brush-like structure, with a color that oscillates from white to green to blue, often with stringy, soft structure. In nature, they're found on decaying organic matter, and they play an essential role in the processes of ecosystem regeneration.

These molds made history thanks to Fleming's discovery of penicillin. The antibiotic made from *Penicillium notatum* marked the beginning of a new era in pharmacology, offering an effective treatment against previously lethal bacterial infections such as pneumonia, rheumatic fever, gonorrhea, and various forms of sepsis. Penicillin interferes with bacteria's ability to form the cell wall essential for their survival. This drug also paved the way for a broad category of antibiotics, with many variants that, over time, have extended their range of action and effectiveness. Other species of *Penicillium* are used industrially for the production of enzymes, organic acids, and other compounds. Some, for example, are employed in the production of cheeses, such as Roquefort and Gorgonzola, in which they help define flavor and texture.

FUN FACTS ABOUT FUNGI

PAUL STAMETS

The most important living mycologist, this American scholar, known for his skill as a communicator and his fungal activism, is a fervent supporter of the medicinal and eco-restorative properties of fungi. He has written various books on the subject, the most famous of which is *Mycelium Running: How Mushrooms Can Help Save the World*.

MYCORENEWAL

The rhizomatic, filamentous dispersal of tiny fungal hyphae enabled plants to gain a foothold on land and, ultimately, life to emerge from the water. Just as they create it, fungi are also able to destroy organic matter, thus placing it back at the disposal of the life cycle, and even more interesting is their ability to degrade pollutants and toxins. Fungi create and destroy; in short, fungi are akin to gods.

PLEUROTUS OSTREATUS

OYSTER MUSHROOM

The oyster mushroom Is one of the most popular and most cultivated mycetes in the world. Known for its delicate flavor and fleshy consistency, it's also important for its ability to regenerate the environment.

The *Pleurotus ostreatus* displays a cap—well, usually a small fleet of caps shaped like fans or, as the name says, oysters—ranging in color from pearl gray to brown, with a short stem that's often positioned laterally. The oyster mushroom is common in temperate regions throughout the northern hemisphere, where it grows on the trunks of dead or dying trees, contributing to the process of nutrient recycling in the ecosystem. Today, it's cultivated on substrata containing sawdust, straw, or agricultural residues, partly because it's widely commercialized as an edible mushroom and valued for its delicate flavor, vaguely reminiscent of the porcino.

It's a versatile ingredient in the kitchen but is being discussed here for another reason: the oyster mushroom has a notable ability to decompose complex organic compounds, including lignin, cellulose, and even some pollutants, transforming them into simpler, less-harmful substances. Its ability to degrade lignin—the main component of wood—is quite exceptional, a quality that allows it to offer an important contribution to the nutrient cycle in forest ecosystems. *P. ostreatus* is also studied for its ability to reduce environmental contaminants, like heavy metals and aromatic polycyclic hydrocarbons, in both soil and water. This process, known as bio-renewal, makes it a promising candidate for the cleanup of polluted environments. Its potential in the mycorenewal field also extends to wastewater treatment and the bioremediation of contaminated sites.

MYCORENEWAL

COPRINUS COMATUS

SHAGGY INK CAP OR SHAGGY MANE

The shaggy ink cap is unmistakable: it's as though it were wearing a wedding dress, but when it ages, it begins to peel, exuding a jet-black ink.

Coprinus comatus is found in fertilized pastures, in what's called an excremental environment, a veritable ecosystem. It can also be found in grassy areas between woods and roads, grasslands, and gardens. It's worth picking, since it's delicious as long as it isn't too open.

Because it's ephemeral, if you find one, you'd better run home (after picking, it deteriorates within an hour). Once you're in the kitchen, slice it very thin and pan-fry it with a little butter to exalt its delicate flavor.

Recognizing it is easy: it has a long, nearly cylindrical cap, covered by thin scales, which give it a vaguely feathered appearance. Initially white, it tends to blacken and melt into rivulets of ink when it matures. The stem is high and slender, with a ring.

The *C. comatus* also possesses significant mycorenewal capabilities, particularly in the degradation of organic pollutants. It's demonstrated its effectiveness in the decomposition of various types of byproducts, including agricultural residues, and its ability to degrade compounds like cellulose and lignin makes it useful in waste treatment and compost production. What's more, there are studies that explore its use in the bio-renewal of soils contaminated by hydrocarbons and other chemical pollutants. Its ability to absorb and decompose these strongly toxic compounds makes the shaggy ink cap an interesting candidate for the purification of various polluted environments.

MYCORENEWAL

HYPSIZYGUS ULMARIUS

ELM OYSTER MUSHROOM

The elm oyster mushroom, master of the art of recycling, conceals an enzyme that can even break down plastic.

Native to the temperate regions of the northern hemisphere, the *Hypsizygus ulmarius* has a thick, fleshy cap that varies in color from white to cream, and a robust stem. It can grow solitary or in groups on broken but living parts of hardwood branches and trunks and is particularly partial to the elm and the maple, fructifying between August and December. It's sought after for its delicate flavor and tough consistency.

The *H. ulmarius* also has interesting properties in the field of mycorenewal, particularly in terms of the degradation of lignocellulosic substances. This fungus, in fact, can break down lignin and cellulose, contributing to the process of natural decomposition of forest ecosystems. Its ability to degrade complex organic compounds makes it potentially useful in the management of wood waste and the production of high-quality compost.

Current research is exploring the use of *H. ulmarius* in the bio-reclamation of environments contaminated by toxic substances, such as heavy metals and industrial chemical compounds. The elm oyster mushroom has shown it knows how to get by in a variety of ways: for example, by exploiting the enzyme laccase to decompose the lignin in its tree host. Since this enzyme has low substratum specificity, it can also be utilized to biodegrade very diverse materials, even plastics. Scientists are also studying what factors influence the production of laccase in order to exploit its vast potential. The laccase produced by the elm oyster mushroom has also been proven to break down various colorants, potentially useful for wastewater treatment.

PLEUROTUS PULMONARIUS

INDIAN OYSTER MUSHROOM

Known as the Indian oyster mushroom, this variety of oyster mushroom is valued for its delicate flavor, fleshy consistency, and notable ecological properties.

Pleurotus pulmonarius has a smooth cap with a shape somewhere between an oyster and a fan, and sometimes fructifies by superimposing multiple sequences of caps. If we imagine them as fans, we might think we've been transported to Andalusia in the summer, in the middle of a large group of ladies suffering from the heat. Often gray with cream or brown shades, and with a central, relatively short stem, this mushroom proliferates on dead wood, particularly broadleaf trees, and is often cultivated on sawdust or straw substrata.

While highly valued for its versatility in the kitchen, *P. pulmonarius* also displays notable abilities in the mycorenewal field in the degradation of complex organic compounds, including drastically reducing environmental contaminants like heavy metals or aromatic polycyclic hydrocarbons. Its efficiency in breaking down these elements makes it an interesting candidate for the treatment of compromised sites and the purification of soil and polluted water, and particularly for the treatment of those polluted by polychlorinated dibenzodioxin and furans—persistent environmental contaminants, often industrial byproducts that are found in the environment after incomplete combustion processes and known for their ability to remain in the ecosystem and accumulate in the food chain. This fungus sublimates them through fermentation, bringing them to a solid state. In one study, *P. pulmonarius*, used to degrade these contaminants in unsterilized soil, achieved an elimination rate of 96 percent. Not bad, right?

PLEUROTUS ERYNGII

KING TRUMPET OR KING OYSTER MUSHROOM

A popular edible mushroom known as the king trumpet, it's valued both for its gastronomic qualities and its ability to break down phenols.

The king trumpet mushroom has a robust cap between white and light brown, sitting atop a thick, fleshy stem. It's the best known of the "oyster mushrooms," and it is even called the "king oyster." A common mushroom in the Mediterranean area, it grows in symbiosis with the roots of cardoon plants, to which it owes its popular Italian name (*cardoncello*), and it's prized in the kitchen for its compact consistency, which, with a little imagination, is reminiscent of meat. In Italy, it's an important ingredient in various regional recipes, often grilled or cooked in the pan with garlic and parsley. It's also widely cultivated.

Gastronomic features aside, the *Pleurotus eryngii* is studied particularly for its potential in the field of mycorenewal: this fungus is capable of contributing significantly to the purification of ecosystems, thanks to the effectiveness of its ligninolytic enzymes. The king trumpet is particularly successful at degrading phenols, chemical compounds, often the fruit of industrial waste, that are toxic for aquatic organisms and tend to accumulate in the environment, causing long-term harm to ecosystems. Some phenols are also carcinogenic and damage human health through their accumulation in the food chain; their ability to resist biodegradation makes them persistent, but, unfortunately for them, the king trumpet's enzymatic activity manages to break them down, permitting the reclamation of vast polluted areas.

And, as we've mentioned, the king trumpet is also tasty: well, everyone, dig in!

LENTINULA EDODES

SHIITAKE

The first cultivation of mushrooms took place in China roughly two thousand years ago. Wu San Kwung, considered the inventor of the shiitake cultivation, is commemorated with a holiday, and several shrines are dedicated to him in his native town.

Lentinula edodes, known as shiitake, is one of the world's most popular mushrooms. Native to East Asia, it's prized for its notable gastronomic value as well as its multiple beneficial properties. In short, it's one of those mushrooms that could have found a place in almost every chapter in this book, but it's exceptional in the field of mycorenewal.

In Japanese, *shiitake* means "oak mushroom." These mycetes of a light or amber color grow not just on trunks but even on backyard woodpiles, a characteristic that makes them easy to cultivate. To grow your own, try drilling a hole in the trunk of an oak, insert a piece of wood with a shiitake mycelium, and watch it grow. Nutritionally speaking, the *L. edodes* is rich in proteins, B-group vitamins, minerals like selenium and zinc, and antioxidants. It also contains bioactive compounds like lentinan, a polysaccharide that has shown promising effects in the treatment of some forms of cancer and as an immunostimulant. Lastly, the shiitake is effective in degrading polluting compounds and absorbing heavy metals. When activated with vanillin, shiitakes can break down a highly dangerous compound, dichlorophenol, a high-priority environmental pollutant that is, according to the Envrionmental Protection Agency (EPA), harmful to the health of both humans and animals. On their own, shiitakes can degrade dichlorophenol by 15 percent in roughly a month, and when triggered by vanillin, they can eliminate up to 92 percent of it.

MYCORENEWAL

TRAMETES VERSICOLOR

TURKEY TAIL OR CORIOLUS VERSICOLOR

Given the resemblance, it's known as the turkey tail. Throughout the world, it is also known as Coriolus versicolor and is one of the mycetes with the strongest antiviral properties. Its compounds include PSK, a polysaccharide capable of extending the life of cancer sufferers.

In Latin, *versicolor* means "of many colors," and this fungus certainly deserves the name: its superimposed caps can often appear garish, like half-moons of alabaster shavings. Indeed, the *Trametes versicolor* seems made from this sparkling stone, particularly when it displays its more common colors: rusty brown striated with dark bands.

Commonly found while strolling in the woods in North America, it grows in layers, groups, or rows, on old trunks and deciduous tree stumps. A stemless mushroom, it has a flesh that's just millimeters thick but with a tough consistency.

The *T. versicolor* spreads in large quantities, thanks to the enzymes produced by its mycelium capable of exterminating nearly all other fungi fighting to colonize the same woody substrata. Besides paving the way for the proliferation of the *T. versicolor*, these enzymes have multiple uses: some people use them to whiten jean fabric, while certain Native American tribes, such as the Dakota, used them to thicken soups and stews—though, today, due to their woody consistency, they are consumed as a tea or broth, rather than eaten. Nevertheless, the most important quality of the polysaccharides in these mycetes is their ability to stimulate the immune system. The *T. versicolor* is one of the most popular medicinal fungi in Asia, often used in China and Japan to support traditional anticancer treatments.

MYCORENEWAL

AGARICUS BISPORUS

CULTIVATED MUSHROOM OR CHAMPIGNON

In France, it's the mushroom par excellence, so much so that the word they use for it there, champignon, *means "mushroom."*

Needing no introduction, it's perhaps the most-consumed edible mushroom in the world, standing out thanks to its delicate flavor and enormous culinary versatility. In this case, describing it is superfluous; suffice it to say that it grows in richly fertilized environments and that it's easily cultivated.

Though it's not traditionally known for possessing medicinal properties, recent studies have suggested that the *Agaricus bisporus* can have beneficial effects on health, as well, like strengthening the immune system and preventing certain forms of cancer, thanks to the presence of antioxidants and bioactive compounds.

Nor should the champignon's contribution in the field of mycorenewal be underestimated: a saprophytic fungus, the *A. bisporus* plays an important ecological role in the decomposition of organic matter, transforming vegetal residues into nutritious compounds newly available to the ecosystem's life cycle. This process contributes to the health of the soil, improving its fertility and structure. In addition, the cultivated mushroom has been proven successful—as have other fungi, including the *Phanerochaete chrysosporium,* the *Trametes versicolor,* and the *Pleurotus ostreatus*—in the removal and recovery of heavy metals from polluted environments. It's worth knowing that mushrooms revitalize contaminated soil with three strategies: biodegradation, bioconversion, and bio-absorption.

STROPHARIA RUGOSOANNULATA

KING STROPHARIA OR WINE CAP

According to Paul Stamets, the world's most famous mycologist, the wine cap stropharia is the best mushroom to grow in your garden. Let's find out why.

"I'm often asked," wrote Paul Stamets on Instagram, "what the best mushroom is to plant in your garden. Based on my decades-long experience, it's by far the garden giant, also known as the king stropharia." The reason for this statement lies in the wine cap's ability to be both a primary and a secondary decomposer that, once introduced into woodchip mulch, can set up shop and proliferate for several years in just a tiny section of soil. Once it's entrenched, the wine cap stropharia turns into an ally for the vast majority of the plants in the garden. One of this mushroom's properties is that it feeds on nematodes, small wormlike parasites that harm the roots of many vegetables. And when it fructifies—from spring to autumn—it can become huge, thus quite spectacular. Not to mention the fact that, besides being edible, it's also tasty.

Additionally, the wine cap stropharia enriches the terrain by its presence and its virtues in mycorenewal: for example, it's the best in the business at filtering wastewater to remove the bacterium *E. coli*, a quality that could be further exploited in purifying water on a far larger scale than in your garden. This fungus can degrade a good variety of polluting substances, including aromatic polycyclic hydrocarbons and heavy metals, making it useful in the bioremediation of contaminated soil while simultaneously regenerating the health of the earth.

MYCORENEWAL

PHANEROCHAETE CHRYSOSPORIUM

CRUST FUNGUS

This fungus is small, crusty, and a model in the field of environmental biotechnology.

This fungus is especially renowned for its extraordinary ability to degrade lignin and other tough organic compounds. *Phanerochaete chrysosporium* produces a white and wooly mycelium, rarely developing fructifying structures in nature. It's commonly found on rotting wood, contributing to the process of decomposition and the recycling of nutrients in forest ecosystems. It has been widely studied for its enzymatic properties, particularly the production of ligninase and peroxidase, key enzymes in the degradation of lignin. The centrality of *P. chrysosporium* in the mycorenewal field is due to its capacity to mineralize a vast range of complex organic compounds and environmental pollutants, including aromatic polycyclic hydrocarbons, synthetic dyes, pesticides, and phenolic compounds, a characteristic that makes it particularly precious in the bioremediation of soil and polluted water. Additionally, *P. chrysosporium* has been the subject of numerous studies for its potential in the cellulose and paper industries, as well as in the production of biofuels and other biotechnological processes, thanks to its ability to degrade and transform cellulose and other polysaccharides. Its ability to break down complex organic compounds offers solutions for pollution management and the development of sustainable biotechnological processes. Research on this fungus is so encouraging that it allows us to imagine new frontiers in the field of industrial sustainability.

FUN FACTS ABOUT FUNGI

AMAZON MYCORENEWAL PROJECT

A pioneering initiative that uses fungi to decontaminate areas devastated by exhausted oil deposits in the Ecuadorian forest. The idea is to exploit the ability of fungi to break down pollutants, thus regenerating the soil.

INCREDIBLE (OR BIZARRE) FUNGI

Fungi are certainly among the more peculiar organisms on nature's menu, yet some of them are so strange that they deserve a separate chapter. Where else do you put the zombie-ant fungi, mushrooms that design fairy circles or light up at night like fireflies, those that live in outer space, or even the fungi to whom we owe bread, beer, wine, and the processes of fermentation?

INCREDIBLE (OR BIZARRE) FUNGI

OPHIOCORDYCEPS UNILATERALIS

ZOMBIE-ANT FUNGUS

Zombies exist, and they're ants controlled by fungal alchemists. The species of the Ophiocordyceps *genus also attack grasshoppers, spiders, beetles, and locusts: to maneuver them, they take control of their muscles but not their brain, leaving the host animals conscious of their desperate condition.*

Ophiocordyceps unilateralis lives in the bodies of carpenter ants, taking control of them in order to spread its spores and complete its life cycle. When colonized by the fungus, the ants are forced by the parasite to make their way up the closest plant, disregarding their natural fear of heights. This is "peak disease." At the right moment, the fungus forces the ant to clamp its jaws around a leaf—a fatal bite. The *Ophiocordyceps* drives the insect to tighten its jaws at precise points: oriented according to the position of the sun and 9.8 inches (25 cm) off the ground, where the temperature and humidity are ideal for fructification. The mycelium passes through the insect's legs, gluing it to the plant, then digests its body and thrusts a stem out through its head. From here rain down spores that are ready to infect the ants below.

The *Ophiocordyceps* is now a prosthesis of the ant: 40 percent of the insect's biomass is now fungus. Researchers think that the mycete can manipulate the ants thanks to substances whose properties are still unknown that act on the central nervous system. What we do know is that the *Ophiocordyceps* is capable of producing the same family of active principles from which LSD is derived. The traits of the *Ophiocordyceps*'s genome responsible for the synthesis of these alkaloids are activated in the ant, which might have a role in the insect's manipulation.

INCREDIBLE (OR BIZARRE) FUNGI

NEONOTHOPANUS GARDNERI

FLOR-DE-COCO

In Brazil, it's called *flor-de-coco* (coconut flower), a name that refers to the preferred habitat of this rare, incredibly bioluminescent fungus, which loves proliferating near palm stumps.

The *Neonothopanus gardneri* is a relatively rare fungus but one that knows how to be noticed. It has a cap ranging in color from brown to yellowish and a diameter that can reach the size of a saucer. Its peculiarity is that it lights up at night—both in the mycelium and the fruiting body. This fascinating phenomenon is caused by a series of chemical reactions that produce light without emitting heat. The flor-de-coco grows mainly on the ground, often around palm trees, in tropical forests. It can be found, though none too easily, in Brazil, particularly in Chapada dos Veadeiros National Park, but it has also been documented in other parts of South America. The flor-de-coco's bioluminescence has quite understandably given rise to a series of myths and local legends. But its ability to illuminate the dark tropical nights hasn't merely added poetry and mystery to the Brazilian landscape; it's also driven mycologists to investigate why and how this occurs. What's known at present is that the bioluminescent mycelium of the *N. gardneri* is regulated by a circadian rhythm that itself depends on temperature. The scientists who have studied it hypothesize that by increasing their bioluminescence at night, the fungi are more successful in attracting insects, which spread the fungi's spores.

INCREDIBLE (OR BIZARRE) FUNGI

OMPHALOTUS ILLUDENS

JACK-O'-LANTERN MUSHROOM

In the United States, it's known as the jack-o'-lantern mushroom, a name that alludes to its allegedly mischievous nature; thanks to its bioluminescence, indeed, the mushroom may recall the pumpkins carved on Halloween.

"According to the Bible," states Lawrence Millman in his interesting book *Fungipedia*, "the so-called Burning Bush seen by Moses on Mount Horeb was on fire, but it did not actually burn. This paradox suggests that the shrub might have been a cluster of bioluminescent mushrooms, which Moses, whose mycological acumen was probably nil, mistook for a bush." And who knows, that shrub may even have been made up of a clump of *Omphalotus illudens*, one of the best-known lantern mushrooms in the world, though it seems that it only tends to light up in North America. . . . At night, certain fungi emit pale, greenish light, a glow strong enough to make an American soldier stationed in New Guinea during World War II write to his wife: "Dear, I'm writing you this letter by mushroom-light."

But how do these mushrooms light up? By means of a pigment called luciferin that, when oxidized by the enzyme luciferase, produces light. The explanation most in vogue among mycologists holds that this serves to attract nocturnal insects, encouraging them to spread the fungi's spores. In the case of *O. illudens*, the cap has a smooth surface with a thick and wrinkled edge, and the glowing depends on its gills. To find a jack-o'-lantern mushroom, your best bet is to look in the eastern regions of North America, though there have been sightings in other parts of the world. Despite its bioluminescence, *O. illudens* is known for being quite toxic, and, worse still, it resembles edible mushrooms such as *Pleurotus ostreatus*.

INCREDIBLE (OR BIZARRE) FUNGI

MARASMIUS OREADES

FAIRY RING MUSHROOM

It is said that fairy rings form when a group of fairies rush frantically in a circle on a night with a full moon; after all the phosphorescent crackling and sparks from the night's activities are over, at dawn, all that's left is a telling ring of mushrooms.

Of the roughly sixty species capable of designing these fascinating rings, the best known and most common is certainly *Marasmius oreades*, understandably known as the fairy ring mushroom. But how does it perform this fascinating magic trick, appearing in a meadow as an almost perfect circle composed exclusively of mushrooms? It depends on the mycelium—the actual fungal body that, as it grows underground, tends to drain its portion of soil of the nutrients it would need to fructify, creating what mycologists call a necrotic zone. By stretching out, however, the mycelium manages to find the necessary nutrients and thus bears fruit at the circular edges of its extension, creating a ring, whose diameter, depending on the circumstances, can potentially expand by several inches each year. We can imagine that the guests at the nocturnal Sabbath might include an additional fairy the next time around.

The *M. oreades* has a small cap with a diameter of 0.8 to 2 inches (2 to 5 cm) and a color between beige and light brown, often with a darker tone in the center. A distinctive characteristic of this mushroom is its ability to be dehydrated and rehydrated without harm, which allows it to survive periods of drought. The fairy ring mushroom is found both in Eurasia and North America, seeking out well-drained meadows and open spaces. It's also worth knowing that it's a highly valued mushroom in the kitchen, thanks to its hazelnutty flavor and tough consistency.

INCREDIBLE (OR BIZARRE) FUNGI

MITRULA PALUDOSA

SWAMP BEACON

If you're gazing at a swamp from the height of a fairy or a Smurf and you see a spattering of slender, yellow, vaguely phosphorescent beacons, you aren't necessarily immersed in the pages of a fantasy novel. . . .

There are fungi that live in the water, or quite close to it, at any rate; put another way, all fungi need a little water, but some, the aquatic fungi, need it in great abundance. These are usually ascomycetes (sac fungi) that prosper near rotting, wet organic matter at the edges of fresh waterways, ditches, and swampy areas. Some of the most fascinating of all of them are the mycetes of the *Mitrula* genus, which is quite vast and whose principal representative is certainly the *Mitrula paludosa*. These tiny fungi have a color range between yellow and orange and a characteristic elongated stick form; they feed on the trunks and roots of aquatic plants and on rotting leaves. They can be slightly bioluminescent, as suggested by their most common nickname, the swamp beacon. Their scientific name, however, refers both to the shape of the cap (*Mitrula*), reminiscent of a miter, and their habitat of reference (*paludosa*), indicating an association with swamps and bogs, for the *M. paludosa* prospers precisely in places like this, often emerging directly from shallow waters. Its geographical distribution is far-reaching, and it can be sighted in Europe, Asia, and North America. These fascinating little fungi also play an important ecological role, triggering the "soft rot" decomposition process that takes place even in conditions of low oxygenation.

INCREDIBLE (OR BIZARRE) FUNGI

CLATHRUS RUBER

LANTERN FUNGUS OR BASKET STINKHORN

Would you ever have imagined contemplating a bloodred dodecahedron and discovering that it wasn't the symbol of some esoteric initiation rite but a fungus?

Well, that's the situation. And it's no coincidence that this quite peculiar mycete is known as the lantern fungus—it can resemble the frame of a complex lamp, inside of which all that's missing is a light bulb—or even as the basket stinkhorn, perhaps because of its rather unpleasant odor. The fruiting body, quite ephemeral, looks like a red cage formed by a polyhedral lattice structure, held together by geometrically entwined branches. It grows both in groups and individually, often near wooden debris in gardens and cultivated soil, revealing itself as a saprophytic organism that feeds on decaying matter. Prior to the opening of its Masonic-style volva, the fruiting body resembles an egg and can reach 2.3 inches (6 cm) in diameter. Curiously, the actual fruit springs from the egg in just minutes, leaving the remains of its containment membrane torn at its base; then it shrivels and collapses onto itself after roughly twenty-four hours. After a few days, not a trace of fructification remains. The *Clathrus ruber* varies in color from red to pale orange, depending on environmental conditions. It has a strong smell similar to rotting meat, and it's believed that this serves to attract flies and other insects in the hopes that they spread its spores. Though humans are quite attracted to it, thanks to its shape, *C. ruber* isn't edible and has no significant uses, but nevertheless it has been introduced in certain areas for purely decorative reasons, and for the same purpose, it's often cultivated for educational reasons in mycology classes.

INCREDIBLE (OR BIZARRE) FUNGI

SACCHAROMYCES CEREVISIAE

BREWER'S YEAST

If you're forced to get up in the morning and go to work, it's not the fault of the fish that emerged from the water bringing life onto dry land but rather is due to humans' choice to quit the nomadic life and grow cereals, cultivated thanks to a fungus that makes flour rise.

Misunderstood as it is, a fungus lies at the very foundation of the structure of our civilizations: it's *Saccharomyces cerevisiae*, or brewer's yeast, used ever since antiquity for the production of bread, wine, and—obviously—beer. *S. cerevisiae* is a single-cell fungus that reproduces by gemmation. We usually call fungi like this yeasts, indispensable for making bread and in alcoholic fermentation. Thanks to its widespread use, brewer's yeast has also proven to be a model organism for scientific research. In nature, yeast cells are present particularly on mature fruit, like grapes, though they can actually be found everywhere, from the wood of oak trees to our own bodies. Since they're not spread via the wind, *S. cerevisiae* needs a carrier to move, like wasps. During fermentation, *S. cerevisiae* converts glucose into ethanol and carbon dioxide, two processes crucial for bread making and the production of alcoholic beverages. Moreover, these yeast cells also have a role in the fermentation of other foods, such as *tapai*, a fermented rice–based sweet-and-sour paste typical of East and Southeast Asia. In the course of history, bakers obtained yeast from beer producers, which led to fermented breads lacking in acidity. Over time, beer producers gradually shifted from high-fermentation yeast (*S. cerevisiae*) to its low-fermentation counterpart (*Saccharomyces pastorianus*).

INCREDIBLE (OR BIZARRE) FUNGI

PHALLUS IMPUDICUS

COMMON STINKHORN

At least it's easy to recognize.

The *Phallus impudicus* is a mushroom whose Latin name doesn't leave much to the imagination: it's an "impudent penis." Identification in this case is pretty straightforward: a vertical mushroom rising from an underground egg with a white stem topped by a brown or greenish cap (the gleba, in this case covered by mucus and wholly similar to a glans) with a small hole on top. Like the other fungi of the *Phallales* order, the *P. impudicus* is also easily identifiable thanks to its diabolical odor reminiscent of rotting meat—useful, as always in these cases, for attracting flies to spread its spores.

Its summary description concluded, it's worth glancing at a few of the inevitable anecdotes. After seeing one, philosopher Henry David Thoreau noted in his journal: "Who knows what Nature was thinking when she created it? She's sunk to the level of those who draw in public toilets." Charles Darwin's daughter apparently gathered up every *P. impudicus* she could find near her estate and burned them, fearing that the mere sight of them could compromise the moral virtues of her female servants. Near the Ozark Plateau in the United States, adolescent girls used to dance naked around exemplars of *P. impudicus* in the attempt to attract virile husbands. The Iban lowland community of Sarawak in Malaysia believes the mushroom to be the penis of an enemy warrior fallen in battle and stays clear of it (in case it should ever try to exact revenge). In various parts of Africa, finally, the gleba of the *P. impudicus* is rubbed on young women to make them fertile.

INCREDIBLE (OR BIZARRE) FUNGI

CIRCINARIA GYROSA

A LICHEN (THAT SURVIVES IN OUTER SPACE)

Some people may not know that the most resistant lichens are able to recover all their irrepressible zest even after long and exhausting space excursions. . . .

People might overlook this as well: lichens are fungi. And if it's true that they survive in space, there might actually be something to the theory of panspermia—the idea that life spreads through deep space by traveling aboard comets. However, this is still a theory, so we'll try to avoid getting sidetracked.

Let's focus on what *Circinaria gyrosa*, the most resilient lichen of all, is able to do. Its survival capabilities are so great that, recently, people have actually tried bombing it with radiation—more intense than anything it would be subjected to in space—you know, just to test out its limits. Obviously, at a certain point, even poor *C. gyrosa* dies, but the amount of radiation necessary to kill it is incredibly high. Exposed to a dose twelve thousand times greater than what's lethal for humans, the samples of this lichen didn't even flinch. It easily outstrips even tardigrades, highly resistant in their own right. To make a long story short, it would even survive on Mars. In fact, the idea behind the experiments was to test out in real time its potential ability to make the cut on the Red Planet; but after an hour of "life on Mars," scientists discovered what should have been easily imaginable even from down here: the test should have been conducted on a Saturday night, when the social scene on Mars picks up a bit. Other than that, it's dead calm, so much so that after an hour, the lichens had reduced their photosynthetic activity almost to zero. They remained in a state of quiescence throughout their time in the incubator and resumed their normal activity thirty days later, once they were rehydrated.

INCREDIBLE (OR BIZARRE) FUNGI

ASPERGILLUS ORYZAE

KOJI

Known in Japan as *koji*, this mold is one of the most used and most important fungi in the world, at least from a gastronomical standpoint, and we're indebted to it for some of East Asia's most famous dishes.

Aspergillus oryzae is the threadlike mold that triggers the fermentation process that transforms simple ingredients like rice, soy, barley, and potatoes into products rich in flavors and aromas. First mentioned in the Chinese *Zhouli* (the book of ceremonies of the Zhou dynasty), the use of koji has since constituted an essential ingredient in the cuisines of the Far East; one might even say that this is the secret of their distinctive character. For centuries, koji has been used in the fermentation of rice to make sake, the flagship of Japanese alcoholic beverages. Koji's ability to saccharify grains also makes it perfect for the production of shōchū, another popular alcohol that boasts an extremely wide range of flavors, from the sweetest and most delicate to the most aromatically complex. But the magic set off by *A. oryzae* isn't limited to the creation of beverages: it's also fundamental in the production of soy sauce, one of the world's most popular condiments, as well as miso, a fermented soy paste that's essential to many traditional Japanese dishes. From a chemical standpoint, the process begins with the transformation of koji into amylase and protease, enzymes that break down starches and proteins, liberating sugars and amino acids that give fermented products their unmistakable flavor. What makes koji perfect for culinary use is precisely its capacity to initiate fermentation without producing toxins. *A. oryzae* has also proven to be a precious resource in the biotech field.

— FUN FACTS ABOUT FUNGI —

WOOD WIDE WEB

Many people are unaware of the network of hyphae that connects the world's plants. It's the Wood Wide Web, the underground lattice of mycorrhizal fungi that permits an exchange of nutrients and information, helping plants improve their resistance to stress and disease. What do the fungi get out of it? Simple: the health of ecosystems is theirs as well.

DELICIOUS FUNGI

PORCINO

CAESAR'S MUSHROOM OR OVOLO BUONO

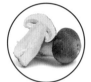
MATSUTAKE

PIEDMONT WHITE TRUFFLE

MILLER MUSHROOM OR SWEETBREAD MUSHROOM

HEN-OF-THE-WOOD OR MAITAKE

OX TONGUE OR BEEFSTEAK POLYPORE

BLACK TRUMPET OR HORN OF PLENTY

ST. GEORGE'S MUSHROOM

LITTLE OAK PORCINO OR ORANGE BOLETE

PARASOL MUSHROOM

CORN SMUT

VISIONARY FUNGI

FLY AGARIC

MAGIC MUSHROOMS

ERGOT

LAUGHING GYM

BROWN HAY OR MOWER'S MUSHROOM

WILLOW SHIELD

GREEN-FLUSH FIBERCAP

MAGIC CONE CAP, YA'NTE, TA'A'YA, OR TAMU

PANTHER CAP

POISONOUS FUNGI

DEATH CAP

VALLEY FEVER FUNGUS

FOOL'S MUSHROOM OR SPRING DESTROYING ANGEL

OLIVE MUSHROOM

SATAN'S BOLETE

FALSE MOREL

FOOL'S WEBCAP

COMMON EARTHBALL OR PIGSKIN POISON PUFFBALL

FUNERAL BELL

MEDICINAL FUNGI

ALMOND MUSHROOM OR MUSHROOM OF THE SUN

MESHIMAKOBU, SONG GEN, OR SANGHWANG

CHAGA

CHANTERELLE OR GIROLLE

CORDYCEPS

LION'S MANE

REISHI

SHIMEJI OR BEECH MUSHROOM

AGARIKON

PENICILLIUM

MYCORENEWAL

OYSTER MUSHROOM

SHAGGY INK CAP OR SHAGGY MANE

ELM OYSTER MUSHROOM

INDIAN OYSTER MUSHROOM

KING TRUMPET OR KING OYSTER MUSHROOM

SHIITAKE

TURKEY TAIL OR CORIOLUS VERSICOLOR

CULTIVATED MUSHROOM OR CHAMPIGNON

KING STROPHARIA OR WINE CAP

CRUST FUNGUS

INCREDIBLE (OR BIZARRE) FUNGI

ZOMBIE-ANT FUNGUS

FLOR-DE-COCO

JACK-O'-LANTERN MUSHROOM

FAIRY RING MUSHROOM

SWAMP BEACON

LANTERN FUNGUS OR BASKET STINKHORN

BREWER'S YEAST

COMMON STINKHORN

A LICHEN (THAT SURVIVES IN OUTER SPACE)

KOJI

FEDERICO DI VITA

AUTHOR

Born in Rome, he lives in Tuscany and writes about food, psychedelia, and culture for various magazines. He has written several books and edited the collective volume *La scommessa psichedelica* (Quodlibet, 2020). Since January 2021, he has produced *Illuminismo psichedelico*, a podcast dedicated entirely to psychedelia.

FLORENCIA DIAZ

ILLUSTRATOR

Born in Ushuaia, in Tierra del Fuego, Argentina, she trained as a teacher of the plastic arts in the Faculty of Fine Arts of the National University of La Plata in Buenos Aires and set off on a journey outside of her native country that is still ongoing. Today, she lives in Costa Rica, where she draws ceaselessly under the name Flor Floripondia for her ecological illustration project and dedicates herself to the study of fungi as magical and decisive elements in every ecosystem.

Powerful Mushrooms: An Illustrated Anthology copyright © 2025 by Vivida. All rights reserved. Printed in China. No part of this book may be used or reproduced in any manner whatsoever without written permission except in the case of reprints in the context of reviews.

Vivida

VividaTM is a trademark property of White Star s.r.l.
2024 White Star s.r.l.
Piazzale Luigi Cadorna, 6
20123 Milan, Italy
www.whitestar.it
www.vividabooks.com

Andrews McMeel Publishing
a division of Andrews McMeel Universal
1130 Walnut Street, Kansas City, Missouri 64106

www.andrewsmcmeel.com

25 26 27 28 29 SDB 10 9 8 7 6 5 4 3 2 1

ISBN: 978-1-5248-9560-0

Library of Congress Control Number: 2024941025

Editor: Katie Gould
Art Director: Holly Swayne
Production Editor: Elizabeth A. Garcia
Production Manager: Julie Skalla

ATTENTION: SCHOOLS AND BUSINESSES

Andrews McMeel books are available at quantity discounts with bulk purchase for educational, business, or sales promotional use. For information, please e-mail the Andrews McMeel Publishing Special Sales Department: sales@andrewsmcmeel.com.